GET
STARTED
WITH
Gouache

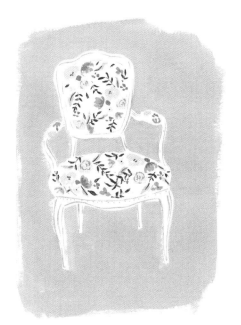
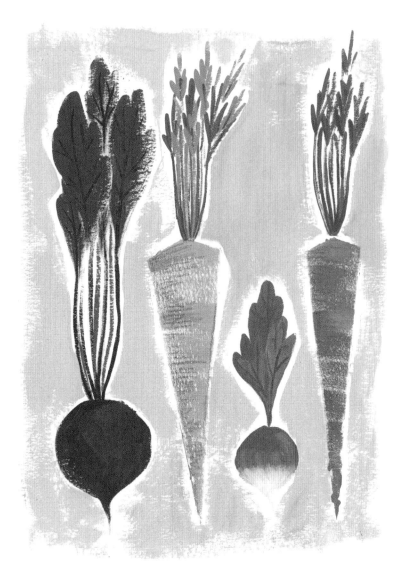
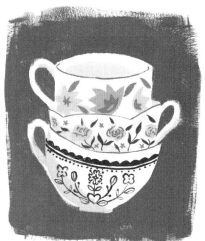
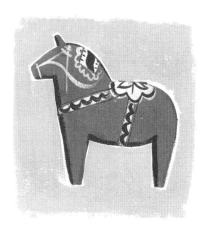

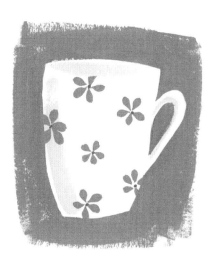

GET STARTED

WITH

Gouache

A Colorful Guide
to Painting the World
Around You

EMMA BLOCK

WATSON·GUPTILL
CALIFORNIA | NEW YORK

Contents

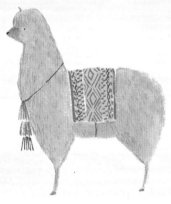

Introduction

Gouache is a fantastic medium that has been under the radar for too long. What is it? How do you use it? How do you pronounce it?

First, it's pronounced either "gwash" or "goo-ash," depending on whom you ask, and it is the love child of watercolor and acrylic paint. Gouache has the rewettable, water-soluble nature of watercolors, with the opaque layering capabilities of acrylic. However, unlike acrylic, gouache dries to a flat matte finish rather than a shiny, plasticlike one. There is something irresistible about the rich colors, velvety matte finish, and beautiful textures produced with gouache. It can be used to create paintings with fine, intricate details, as well as work with bolder, expressive brushstrokes. It also lends itself to a mixed-media approach because it combines well with colored pencils, watercolors, collage, and India ink.

While painting with gouache might seem daunting at the beginning, there are actually many reasons why this is a great paint for amateurs and professionals alike. Gouache dries very quickly, which means you can complete a painting in one sitting, so you don't have wet paintings sitting around drying. Its water-soluble nature makes it easy to clean and look after brushes and palettes. While the paints are opaque (meaning they are not transparent), they can be used like watercolors (which have more clarity) if sufficient water is added to them, making a great all-around paint.

In this book we will uncover the many ways you can use gouache. It's such a versatile paint, and it can be used to create everything from dry, rough texture to subtle and watery washes. By exploring how to use this paint with a variety of techniques, you will build up your skills and confidence. By the end of the book, you may have started to develop your own gouache painting style.

I think the best way to learn is by doing, so with each project you complete you will be learning new skills. There is a mixture of beginner and intermediate projects, meaning this book is appropriate for total beginners, but there are still plenty of projects to engage more experienced artists and to keep you busy as your skills progress. The most important thing is to just have a go and not worry too much about the final result looking perfect. Every time you paint, you learn something, so enjoy the process and keep experimenting.

THE HISTORY OF GOUACHE

The word *gouache* was first used to describe opaque watercolors in France in the eighteenth century; however, there are examples of the use of a gouache-style paint as far back as ninth-century Persian miniatures. Gouache has rarely been used in fine art; only occasionally for preparatory sketches but never for finished pieces, which tend to be created with oil paints. The notable exception to this is Henri Matisse's paper cutouts, which are constructed of thin paper painted with an even layer of colorful gouache and then cut out into the desired shapes.

For decades gouache has been used by illustrators, designers, and animators. Its flat, even finish makes it perfect for creating work that is going to be reproduced. In traditional cel animation, each frame was drawn by hand on a transparent celluloid "cel," and gouache was often the paint of choice for filling in the color. It was also used to create the beautiful painterly backgrounds the cels were laid over. Another application was by concept artists to create the mood and feel for an animation. The work of Mary Blair, a midcentury illustrator and concept artist for Walt Disney Studios who created art for animated films such as *Cinderella*, *Peter Pan*, and *Alice in Wonderland*, is a wonderful example of this.

ME AND GOUACHE

Perhaps it is because gouache has been overlooked in the world of fine art for such a long time that there are so few resources available on it. In five years of formal art education, I never encountered it as a medium; it was only once I graduated that I heard about it through word-of-mouth and began to use it in my work. In this book I intend to lift the lid on this hidden gem of a paint.

I think I first came across a gouache on Instagram after seeing another illustrator use it, which is the way I think a lot of people discover it these days. I bought a set of ten colors from my local art store and immediately loved the effects they could create. I had been struggling with both watercolors and acrylics because they weren't quite giving me the finish I was looking for. Once I discovered gouache, I started using it immediately in my personal and professional work.

The bold, graphic quality of gouache, plus its strong colors, matte finish, and quick drying time all make it perfect for reproducing and printing. The majority of the illustrations I create professionally are painted with gouache, often with a little bit of colored pencil or watercolor as well. It's also my preferred medium for my personal work, and most of my sketchbooks are filled with gouache paintings. Many of the projects in this book are adapted from paintings in my sketchbook, which gives you a real insight into my working methods as an artist.

MATERIALS

If you don't already have a set of gouache paints, then a shopping trip to the art store will be in order, which is always a lot of fun! In the following pages I have listed the essential materials for completing the projects in this book. It's easy to be overwhelmed by choice in an art store, so I recommend starting with the basic range of colors outlined on page 16, and then adding to it as needed.

Paint

I use Designers Gouache from Winsor & Newton throughout this book because it's affordable, of good quality, and readily available. Other good brands of gouache include Holbein, Royal Talens, Caran D'Ache, and Schmincke. Most brands just make one type of gouache, but Schmincke produces a students' range (Akademie) and a professional range (Horadam). Colors tend to be fairly similar across brands; a Yellow Ochre from Winsor & Newton will look similar in color to one from Holbein or Talens. Most sets of gouache will contain similar colors, so no matter what you purchase, you can paint any of the projects in the book, as well as use the color mixing and color theory guides.

TOP TIP

If you have a set of gouache you haven't used in years, it's important to check they are still usable; even with the caps on they can dry up eventually. Gouache is water-soluble; however, when the paint dries up inside a tube it will be impossible to squeeze out. You can cut open a tube of dried-up paint, but this will be a little messy and dangerous, so if a tube is completely dried up the best thing is just to buy a new one.

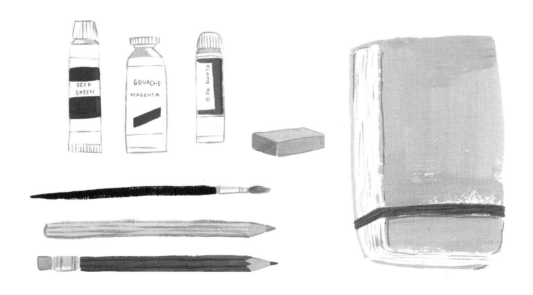

If you don't have all of the colors of gouache that you need, you can mix some white gouache with some watercolors on your palette to create the color you are missing.

Use your judgment when it comes to buying gouache; if the price seems too good to be true, the paint will probably be of inferior quality, and you won't get the best results. The most affordable way to buy paints is usually to start with a set of ten and then buy individual tubes of extra colors separately as you need them. Gouache normally comes in metal tubes with a screw cap, usually in a 14 ml/0.47 fl oz size, although larger and smaller tubes are available. I use a lot of white in my work, so I buy large 34 ml/1.25 fl oz tubes of it. It is possible to buy blocks of solid gouache, the way you can with watercolors; however, I don't recommend using these because it is difficult to achieve a thick, creamy consistency with them.

There are two types of gouache, acrylic and traditional. Acrylic gouache has the matte finish of gouache but the waterproof permanency of acrylic and is available from a few brands. However, I prefer the water-soluble nature of traditional gouache. If you prefer to use acrylic gouache, you can use it to complete all the projects in this book without any problems.

There are twelve colors that you need to complete the projects in the book—Spectrum Red, Flame Red, Permanent Yellow Deep, Primary Yellow, Ultramarine, Primary Blue, Permanent Green Middle, Yellow Ochre, Burnt Umber, Burnt Sienna, Lamp Black, and Permanent White.

Flame Red, Burnt Umber, and Burnt Sienna are very useful colors that I use frequently throughout the book, but aren't always included in sets of paint, so I do recommend trying to buy these separately, if possible.

There are a huge range of colors available; however, I prefer to paint with a smaller set of colors and mix my own variations, rather than having lots of individual tubes of colors that I don't use very often. Starting with a small range of colors is a great way to learn color mixing (see page 18). If you buy a large set of thirty colors, you will often just use color straight from the tube, rather than learning to mix your own and developing your own unique color palette.

Brushes

I like to use synthetic brushes in a range of shapes and sizes when painting with gouache. There is no point in using expensive sable brushes for gouache; the bristles are too soft to control the thick consistency of the paint. Brushes are quite a personal thing, so I recommend buying synthetic brushes from a few different brands when you are starting out, to find the brand that you like best. Brands I like include Pro Arte, Winsor & Newton, and Daler-Rowney. Craft stores often stock good square or angled brushes. When you've found a brand you like, I recommend purchasing four or five round brushes and several square and angled brushes in different sizes.

A round brush is your standard go-to brush, so you should have a selection of round brushes in varying sizes. The smallest brushes will need replacing most often as the bristles wear out.

A square brush is very useful for painting large areas, creating dry texture, and painting straight lines. An angled brush is incredibly useful for painting large areas, making expressive brushstrokes, painting thin lines, and creating texture. A filbert brush is a flat rounded brush useful for filling in large areas.

Throughout the book I refer to small, medium, and large brushes. Because I am a British artist writing for an international audience, I find it simpler to just use these descriptions, rather than specify a certain size brush, which may vary by country.

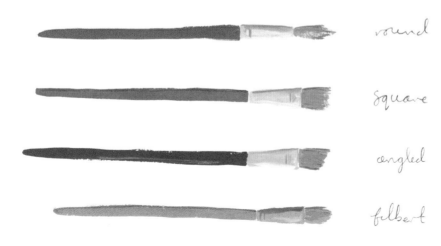

round

square

angled

filbert

Paper

I like to use heavyweight cartridge paper for painting with gouache. Recommended brands for cartridge paper include Daler-Rowney and Fabriano. I prefer to buy pads of paper that are gummed, rather than pads that are ring bound. Sometimes cartridge paper will be advertised as heavyweight; a paper weight of at least 80 pounds (200 gsm) is best. As I tend to use gouache with very little water, I see no need to buy expensive watercolor paper. I like the texture of cartridge paper—it's very subtle but not completely smooth— so it works well for creating fine details, as well as for building up texture with dry brush techniques. The lack of moisture in the paint means it's also unlikely to wrinkle paper and it can be used in a wide variety of sketchbooks. The opaque nature of gouache means that it also works well on colored and black paper.

Pencils

You will need regular graphite pencils for sketching. These don't need to be anything fancy; a regular pencil from a stationery or art supply store will be fine. I also recommend having a selection of good-quality colored pencils, as they work really well with gouache. My favorite brands are Derwent, Caran d'Ache, Stabilo, and Staedtler.

Palettes

I use a variety of palettes; plastic, metal, and ceramic all work well with gouache. If you like, you can wash the palette clean at the end of a session and start with a clean palette the next time you paint; however, I tend to leave the paint on the palette as it can be rewetted and used again next time.

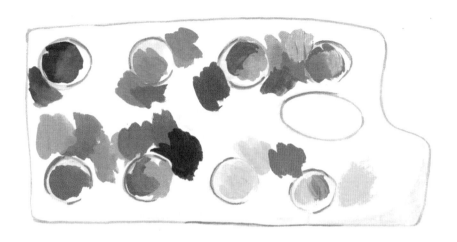

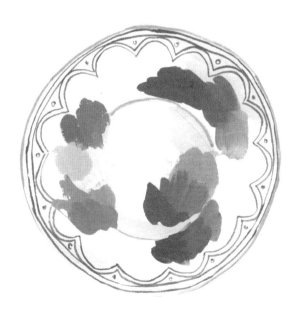

Make sure that you replace the cap on the tube of gouache after squeezing out the paint you require. If you've left the cap off your paint for a little while and the exposed paint is looking a bit dry, you can dunk the end in some clean water before putting the cap back on. The dried-up paint will absorb the water, so next time you take the cap off to use the paint, it should be ready to go. Never stick a paintbrush inside the tube of gouache to get the paint out because it will damage the paintbrush.

Work Space

It's important to find yourself a little work space where you feel comfortable. You should have enough room for a pad of paper or sketchbook, a cup of water (an old coffee cup or glass jar is perfect), a palette, and tubes of paint. Make sure you're working at a proper table that you can put your legs under and have your feet on the ground. A desk or dining table is ideal; a coffee table or breakfast bar is not. When learning to paint as a hobby, painting at a desk or table shouldn't do you any harm. If you are devoting many hours to painting or considering becoming a professional painter, it is worth considering your posture and adjusting your work space to minimize strain. Many artists feel more comfortable working at a standing desk or easel.

Also consider the light if possible. It's important to have good artificial light as well as natural light. A room with bright, direct sunlight that causes harsh shadows can be a difficult place to work in. I know some artists who recommend buying daylight lightbulbs. I recommend experimenting and finding a setup that works best for you.

My desk setup includes a desk lamp, a cup of paintbrushes, a cup of colored pencils, a cup of graphite pencils, a cup of scissors and craft knives, a small cup of razors, a cup of pens, as well as a selection of paints, water for brush washing, a scanner, and a computer. I am fortunate that my home studio is north-facing with large windows, so I have a very cool, even light throughout the day. In the winter I'm often working after it has begun to get dark, and I have an angled desk lamp to make sure I can see my work without straining my eyes.

I usually work on a wooden light box on my desk, which also serves as a desk easel. The light box means that my work is raised up and angled toward me so I don't have to hunch over my desk to see what I'm doing. When I am not using my gouache, I keep the tubes stored in a large pencil case, but a small box or tin works well, too. I also have a shelf above my desk for storing paint palettes and sketchbooks that I find very handy.

Even with my large desk, it often gets messy and cluttered as I'm working, and open tubes of paint, wet paintbrushes, and colored pencils start to litter my work space. For this reason, I recommend tidying as you go along and not leaving the caps off of paints for too long, or allowing paint to dry on brushes when you're not using them.

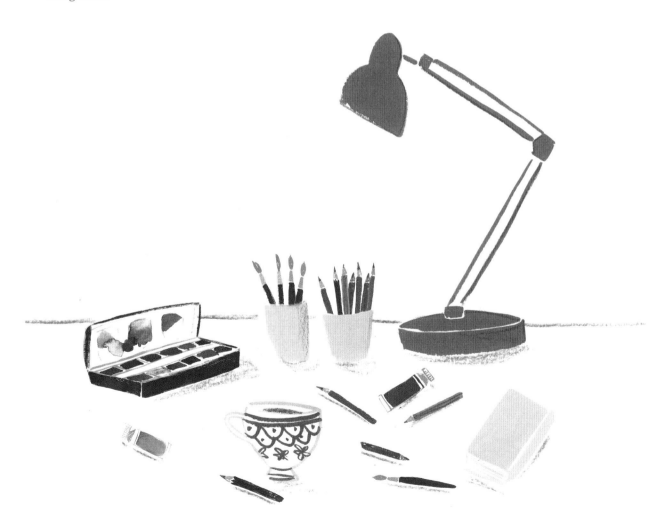

COLOR THEORY

A basic grasp of color theory really helps you to be able to choose and mix colors in a confident and intentional way. Whether you're making up a color or painting what you can see in front of you, your choice of tones, shades, and hues will affect the look and feel of your painting. This section aims to introduce color theory in a simple way that will help you understand how colors interact with each other.

There are three primary colors—red, yellow, and blue. Primary colors cannot be made by mixing any other colors together. By mixing together two primary colors you create a secondary color. Yellow and blue make green, yellow and red make orange, and red and blue make purple. These three colors—orange, green, and purple—are secondary colors. Tertiary colors come in between secondary and primary colors on the color wheel. They are colors that have a high proportion of one primary color, for example a lime green that has lots of yellow in it, or a pink purple with lots of red in it.

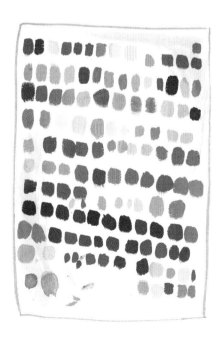

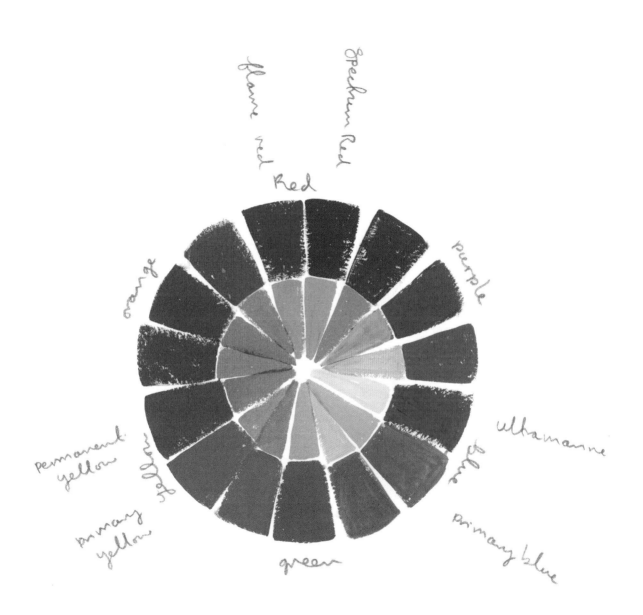

flame red

Spectrum Red

Red

purple

orange

ultramarine

permanent yellow

yellow

blue

primary yellow

primary blue

green

temperature

tone

saturation

hue

Creating Contrast

The way we see the world, and the way a painting works, is due to contrast. When there is no contrast between anything, everything is just a gray blur. We need contrast in temperature (warm and cool), tone (light and dark), saturation (bright and muted), and hue (different colors), to see what's being depicted in a painting. Most paintings will make use of several of these types of contrast. Perhaps a painting has contrasting areas of light and dark, creating a tonal contrast, or perhaps a bright saturated area of color pops out against a muted background. Think about how you use contrast in your painting—what things do you want to stand out and where do you want to draw the viewer's eye? The thing to remember is that how we see colors is always relative to their context. We never see a color in isolation. If you hold a gray piece of paper against a white wall, you would describe it as dark; but if you held the same piece of gray paper against a black wall, you would describe it as light. Whether a color is light or dark, cool or warm, bright or muted really depends on what is next to it.

Here is an example that shows you how differences in temperature, tone, saturation, and hue create contrast.

TEMPERATURE
A mixture of warm and cool pinks creates contrast. The contrast is subtle but you should definitely see the difference between the warmer peachy pinks and the cooler, blue-toned pinks.

TONE
Different tones of the same shade of pink provide contrast, making the leaf appear much darker than the flower. The main way to create differences of tone using gouache is by adding white to create lighter colors. You can also lighten colors by adding water.

SATURATION
Here a mixture of muted and saturated colors is used to create contrast. Notice how the pink flower stands out against the gray leaf.

HUE
Completely different colors are used for the center of the flower to create contrast.

Opposite Colors

As you can see on the color wheel, each primary color has an opposite secondary color. Red is opposite the green, blue is opposite the orange, and yellow is opposite the purple. The way to work out the opposite color without looking at the color wheel is to think of which color isn't used when mixing the secondary colors. No red is used to make green, which is why they are opposite colors. Likewise, no yellow is used to mix purple and no blue is used when mixing orange. You might also hear these combinations of color referred to as complementary colors, as they are said to complement each other; however I prefer to use the phrase *opposite colors* because I think the term is less confusing.

Warm and Cool Colors

You might have previously experienced people describe half of the color wheel as cool (blue, purple, and green) and half as warm (yellow, orange, and red), but this is inaccurate as every color on the color wheel has the ability to be warm or cool. You can get cool green-tinted yellows and warm red-tinted purples. Traditionally, an artist's paint set will consist of a warm and cool set of primary colors. With these colors, plus white, you can mix almost any color you need. If you had just one of each primary color, you would be much more limited in the range of colors you could mix. You need both the warm and cool of each primary color to mix a full range of colors. As well as increasing your mixing possibilities, warm and cool colors add mood to your paintings. You can use a warm or cool color palette to create emotion or atmosphere in a picture.

GETTING STARTED

Now that we've covered some basic theory, it's time to gather up your paints, palette, brushes, and some paper and get started.

The Colors in Your Set

In the paints I have suggested, you have a cool set of primary colors—Spectrum Red, Primary Yellow, and Primary Blue—and a warm set—Flame Red, Permanent Yellow Deep, and Ultramarine. Most sets will also include some greens and browns, but they are there for convenience and are not essential; you can mix them yourself using the primary colors provided. I've also suggested you acquire three earth tones—Yellow Ochre, Burnt Sienna, and Burnt Umber. They are incredibly useful in mixing a range of colors for painting people and animals. I've also included Permanent Green Middle, Lamp Black, and Permanent White. I find that I use a lot of white when painting with gouache to lighten colors and make them more textured and opaque. These are the colors that I use in my own work but, of course, other colors are available. There are many different warm and cool primary colors; I've picked the ones that I enjoy using, but there are other shades that are warmer, cooler, brighter, or darker. To produce results that look most like my examples, I recommend trying to get the exact shades that I use. But if you can't find the exact right color, using one that is a close match will work, too.

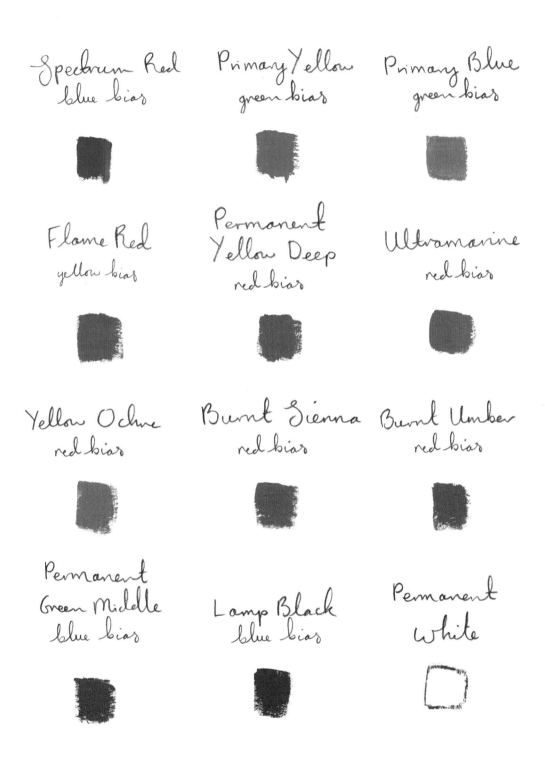

Spectrum Red
blue bias

Primary Yellow
green bias

Primary Blue
green bias

Flame Red
yellow bias

Permanent
Yellow Deep
red bias

Ultramarine
red bias

Yellow Ochre
red bias

Burnt Sienna
red bias

Burnt Umber
red bias

Permanent
Green Middle
blue bias

Lamp Black
blue bias

Permanent
White

How to Mix Paint Efficiently on a Palette

To mix paint efficiently, the first thing to do is to squeeze some of your chosen paint color onto a palette (I often use a palette with wells). Squeeze out the color you will be using the most of. For example, squeeze out white into a well. Next squeeze a small amount of the second color. For example, squeeze out red on the edge of the well. With a brush, gradually add the red to the white until you achieve the shade you're looking for. It's much easier to gradually add the darker color little by little, rather than continuing to add large amounts of the lighter color and ending up with more paint than you need. If I had immediately squeezed equal amounts of red and white into the well and mixed them together, I would have made a very dark shade of pink. If I wanted to lighten it, I would then have to add a large amount of white paint to find the right color. If you know you want to make a dark color, it makes sense to add the white gradually. The same principle goes for adding water: add it gradually, drop by drop, while mixing to find the right consistency. When mixing, make sure that all the colors are combined completely so there aren't streaks of unmixed pigment on the palette or in your brush.

Learning to mix your own colors is really important, which is why I recommend starting with a small set of paints. If you buy a large set of paint with lots of different colors you will probably just use the colors straight from the tube and not build up the confidence to make your own colors. I always recommend using a test swatch of paper when mixing a new color. Then you don't have to worry about making mistakes, and you can learn by experimenting.

As a rule, gouache usually dries darker on paper than it looks on the palette. It can be hard to judge how the color will turn out until it's dry. Gouache can look rather odd as it is drying. If some parts are drying quicker than others, it may look patchy and uneven, but you won't know how it really looks until it is completely dry. This is why it is essential when you're first using gouache to always paint a test swatch of a color and wait for it to dry before using it on a painting.

Mixing Opposite Colors

Opposite colors are a great place to start when building a color palette. By mixing a little bit of the opposite color into the color you're using, you can make it more subtle and muted. By mixing equal amounts together, you will most likely produce a gray or brown. The exercise that follows will show you the range of colors that can be produced by two opposite colors plus white. The color palette this produces is a great starting point for painting because it contains a range of colors that are all harmonious with each other.

TOOLS & MATERIALS

Square brush

COLORS

- Flame Red
- Permanent Yellow Deep
- Permanent White
- Ultramarine

Start by mixing up a warm orange using Flame Red and Permanent Yellow Deep; make enough to fill a well in your palette. Paint a small square of this color. In another well of your palette, mix a bit of the orange with bit of white and paint another square underneath the first. Add more white and paint another square underneath the second.

In another well of your palette, mix a small amount of Ultramarine with the original orange mixture and paint a square of this color next to the first square painted. Add a small amount of white and paint another square below. Add more white and paint another square under the last. Continue this process, creating mixes with more and more blue in them. For the final square use pure Ultramarine. At the end, the color chart should be orange at one end and blue at the other. Notice the huge range of colors created in the middle.

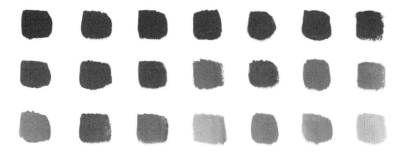

Making a Color Chart

Painting a color chart like the one shown here is a very useful, if time-consuming, initial exercise to introduce you to your set of paints and the range of color-mixing possibilities.

TOOLS & MATERIALS

Pencil

Ruler

Square brush

COLORS

Every color in your paint set.
I have used:

- Spectrum Red
- Flame Red
- Permanent Yellow Deep
- Primary Yellow
- Permanent Green Middle
- Primary Blue

- Ultramarine
- Burnt Umber
- Burnt Sienna
- Yellow Ochre
- Lamp Black
- Permanent White

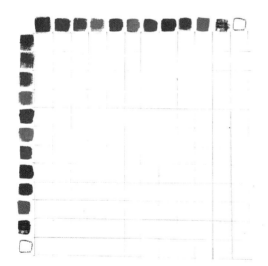

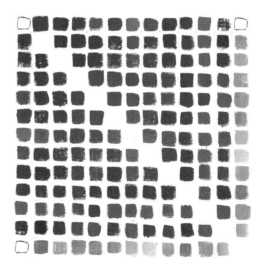

Start by drawing in pencil on a large piece of paper a grid that is twelve 1-inch squares by twelve 1-inch squares. Along the top edge, paint a swatch of each color in your set. Do the same thing down the left side. It's important that they are in the same order going across as going down.

Where each color on the vertical and horizontal axis intersects with another, mix the two colors together and paint in the little square swatch. This process can take a while as you need to wash your brush in between each color mix to get a true mix between the two colors, and you may need several palettes for this. Once the chart is finished you should have something that looks like mine. I've left the central diagonal line of colors blank because we know what each color on its own looks like.

This color chart will give you some idea of the possible mixes that can be created by the colors in your set, but it's really only the tip of the iceberg. By varying the quantities of each color, adding white, or adding a third color, you can create an endless range of colors.

Even now, as a professional illustrator who has been using gouache for years, I still paint test swatches while working. I tend to paint a small swatch, about the size of a fingernail, and wait for it to dry. If it's the correct color, I start painting the final piece; if it's not the correct color, I adjust it and paint another swatch and wait for it to dry. If I'm looking for a very specific color, I often paint many very similar swatches before I find the color I'm looking for. I actually like having these test sheets of paint swatches around the studio. I think they have a real beauty in their own right. If you are very new to color mixing and are struggling to re-create colors that you have mixed before, you can also write on your test swatch what you mixed to create that color.

Undertones

When doing the color mixing exercise on page 20, you might have noticed that mixing black with yellow produces a muted green, or mixing red with black produces a deep purple. Black has a slightly blue undertone that can be useful for creating very subtle greens and purples. Knowing the undertones of the colors in your set can help predict how they will mix. For example, Primary Yellow and Primary Blue mixed together will create a bright, vivid green, as they both have green undertones. Mixing together Permanent Yellow Deep and Ultramarine, which both have red undertones, will create a much more muted shade of green.

Ultramarine (red undertones) and Spectrum Red (blue undertones) combined will create a bright vibrant purple. On the other hand, mixing together Flame Red (yellow undertones) and Primary Blue (green undertones) will create a muted gray. As you can see, the undertones in colors affect the final color produced. If the undertones don't match up with the color you're trying to mix, for example yellow and green undertones in a purple mix, the result will be muted. That is not to say that these colors are in any way wrong, or a mistake. It is incredibly useful to have the ability to mix up subtle and muted colors. The undertones of two colors will help you predict what color they will make when mixed together. You can refer back to our earlier color chart to check the undertone of a color you are using.

Adding Water

Most of the time you will need to mix a little bit of water into your gouache on the palette before using it. There is no right or wrong amount of water to use when painting with gouache—use your best judgment; with practice you will develop an instinct for what type of consistency you are trying to achieve. How much water you need to add will vary; an old tube of paint that has started to dry out might need a lot of water and a lot of mixing; a brand-new tube of paint might only need a little. Generally, the consistency I go for is a paint that feels creamy in texture but is not thin and runny. Often when people are familiar with using watercolors, they tend to add too much water to gouache out of instinct. Try to resist this urge, and add water gradually until you achieve the right consistency. When mixing colors, add the paints you're using to the palette and use a clean brush to add a few drops of water, then mix to combine. Make sure your paint is fully mixed with no area of unmixed color, which will make your painting streaky.

Throughout the book I will specify when to add lots of water to create a thin diluted paint mixture. I will also occasionally specify when to add no water, so that the paint is dry or very opaque. When I don't specify how much water to add, the general rule is to add just a few drops of water, mix the paint well, then decide if it needs additional water. It's good to get to know your set of paints and how much water they require for them to become easily workable.

As an initial exercise, paint a swatch of any color with no water mixed in. Gradually add water, mix it together, and then paint another swatch next to the first one. Keep going until you have achieved a translucent quality in the paint. The first swatch with no water will probably feel difficult to handle on the paper, and the final swatch will resemble watercolor more than gouache. I often use various consistencies of paint within the same painting, and it's good to get used to the feel of gouache with differing amounts of water.

Try the same exercise again, this time on a piece of black paper. You can see as you add the water the opacity of the gouache is reduced. When painting with watercolors, water is used to lighten the color; however, when gouache white is used to lighten the color, adding water makes the paint thinner in consistency, translucent, and causes it to dry less evenly.

Layering Colors

Gouache can be layered up to create detail, depth, and texture. You can either apply a second layer of paint once the first layer is dry, called wet-on-dry, or while it is still wet, called wet-on-wet. If the first layer of paint has already dried by the time you apply the second layer, you will get neat defined edges. If the first layer of paint is still wet when you apply the second layer, the second layer will blend into the first slightly and create a subtler effect. Your second layer of paint can be lighter or darker than the first layer. Because the gouache is opaque, a lighter color will show up against a dark background. If you have made a mistake, you can paint another layer of the same color to cover up the mistake. If you are covering up a dark color with a light color, make sure the mixture is thick and opaque. If the lighter color is thin and watery, the dark color will show through.

Brushstrokes

You might have noticed the way you apply the brush to the paper affects the brushstroke produced. Try painting brushstrokes quickly, slowly, and then with light and heavier pressure. Notice the different effects created. As you press down on the brush, the bristles spread and create a wider brushstroke. A light, fast brushstroke using a round brush creates a thin line, whereas pressing slowly and heavily with the same brush creates a much wider line. A light brushstroke using a square brush might pick up the texture of the paper. You will also notice that as you start to run out of paint on the brush the brushstrokes will appear more textured. Mastering these different brushstrokes can help you paint a whole host of subjects and brings variety to your work. For example, a couple of broad sweeping brushstrokes could be used to create a leaf, which contrasts with a thin, spindly stem. Using contrasting brushstrokes adds interest and a level of sophistication to your work.

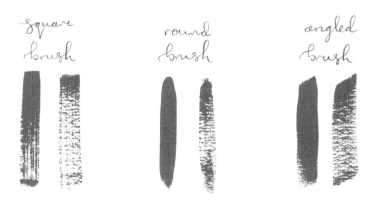

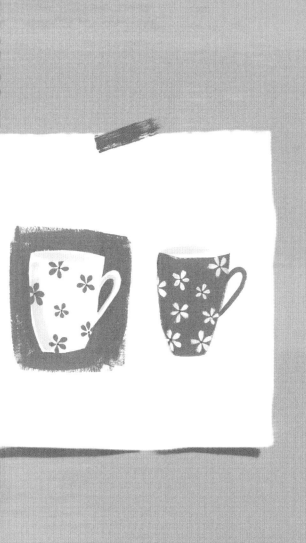
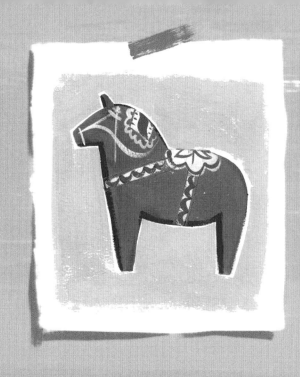
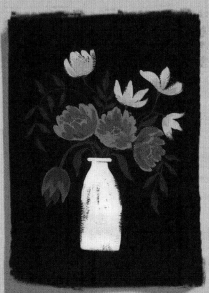
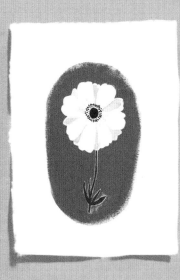

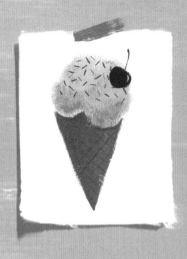

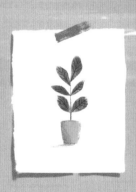

BASIC TECHNIQUES

I have chosen a set of initial exercises to introduce you to some of the basic principles of using gouache: creating texture, diluting it with water, creating expressive brushstrokes, using it on dark paper, creating a limited color palette, and utilizing negative space. We will build on these basic techniques throughout the rest of the book, usually combining a few of the above skills to create a finished piece.

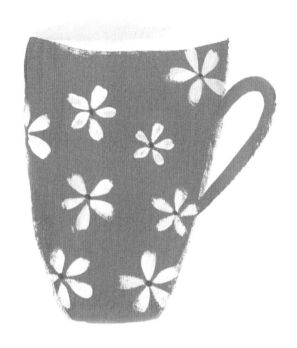

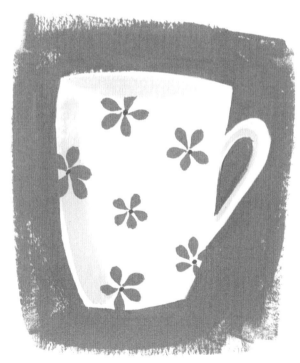

GET STARTED WITH GOUACHE

Working with Negative Space: Coffee Cups

This first simple exercise introduces some of the basic principles of painting with gouache—creating texture, filling in areas of even color, utilizing negative space, and using a variety of brushstrokes.

TOOLS & MATERIALS

Graphite pencil

Medium square brush

Medium round brush

Eraser

Small round brush

COLORS

Permanent Yellow Deep

Flame Red

Permanent White

Lamp Black

01

Start by roughly sketching out two coffee cups side by side using a graphite pencil. You can use my sketch as a reference, or use your own coffee cups to sketch from. Keep the lines of the sketch as light and simple as possible. Even though gouache is opaque, you might be able to see very heavy pencil line through the paint, so it's best to keep them light.

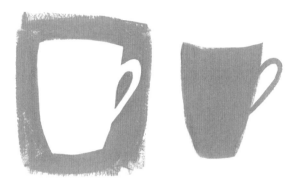

02

Create a mixture of Permanent Yellow Deep, Flame Red, and Permanent White to make a peach color on your palette. (The color in this piece isn't really important, and you can use another color if you prefer.) Add a little bit of water to the paint until you have a smooth, creamy consistency. You will be using this color for most of the painting, so make sure you've mixed enough at the beginning. If you're using a palette with wells, it's a good idea to fill a well with the color.

Using a medium square brush, paint around the outside of the coffee cup sketch on the left. Make broad, flowing brushstrokes following the contour of the coffee cup. Paint the area closest to the coffee cup first, while you have more paint on your brush, and finish toward the edges when your brush is drier, which will create texture. Using a medium round brush, carefully paint the space in between the cup and the handle. Continue to use this brush and the same paint mixture to paint the outside of the coffee cup on the right, including the handle. Once that's dry, rub out all the pencil marks with an eraser.

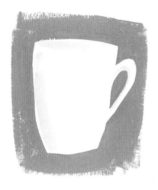 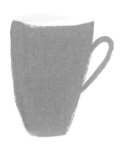 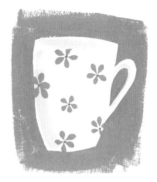

03

Make a pale gray mixture using Permanent White with a tiny bit of Lamp Black. Using a medium round brush, add shadow to the left-hand side of the white cup and its handle and the insides of both coffee cups.

TOP TIP

Gouache is water-soluble, so if you have spare paint left over, you can always re-wet it to use it another time. Just allow it to dry on the palette; when you need it again, add plenty of water and mix thoroughly. The palette can be stored with the rest of your art supplies once the paint on it is completely dry.

04

Once that layer is dry, paint daisies over the white coffee cup using your original paint mixture and your small round brush. To create the daisies, place the point of your brush in the flower center and apply pressure, then gently lift up, creating a teardrop shape. (You might want to practice this technique a few times on a separate piece of paper to get the hang of it.) The more pressure you apply, the larger the petals will be. Don't move or drag the brush while you're doing this. Just gently apply pressure, then lift up. Rotate the paper and do the same thing again. Do this five times to create a perfect daisy.

Paint the daisies randomly across the mug, including some that are cut off at the edges. Using white paint and the same technique, paint daisies on the peach coffee cup. Mix together a small amount of the peach paint mixture and black paint. Using your small brush, add centers to the daisies.

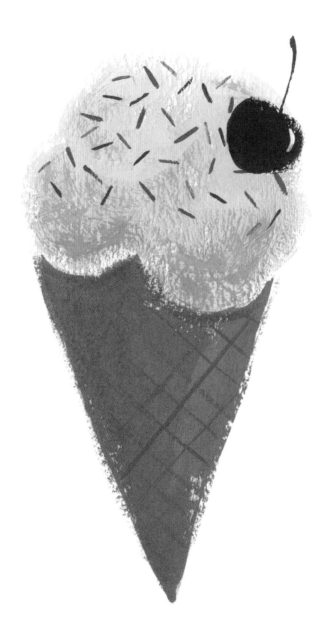

Creating Texture: Ice Cream Cone

Using a square brush to thickly apply paint creates lots of texture and depth. Normally square brushes are used to fill in background or paint straight edges, but in this exercise, we use one to create the soft, textured edges of ice cream. If you don't have a square brush, you can use a large round brush. You can play around with different colors to paint different flavors.

TOOLS & MATERIALS

Pencil

Medium square brush

Medium round brush

Tissue paper (optional)

Small round brush

COLORS

◯ Permanent White

▧ Flame Red

▧ Yellow Ochre

▧ Burnt Sienna

▧ Primary Blue

▧ Permanent Green Middle

▧ Spectrum Red

▧ Lamp Black

01

Roughly sketch out the ice cream and a cone with a pencil.

For the ice cream, mix lots of Permanent White with a small amount of Flame Red and a small amount of water. You only need a very small amount of red, so add it bit by bit until you get the color right. Remember that gouache always dries slightly darker, so what looks like a light pink in the palette might be quite bright. Before you start painting, create a little test swatch and wait for it to dry to check that you like the color and are happy with the texture. We want the paint quite textured so don't add too much water at this stage. Use a medium square brush to thickly apply pink paint to the outline of the ice cream, creating lots of texture.

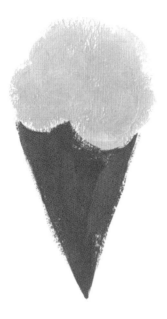

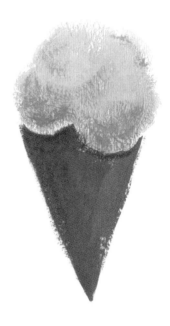

02

While the pink is drying, mix Yellow Ochre, Burnt Sienna, and a little bit of Permanent White to create a warm brown for the cone. Paint the cone using a medium round brush. I've left a little bit of rough texture around the edges to add interest.

03

Using your square brush, add a little bit more Flame Red to the pink mix. Add shadows on the bottom of the ice cream. The slightly dry paint should catch on the dry layer of paint and create lots of texture. If your paint is too wet, or if you have too much paint on your brush, you can take off the excess using some tissue paper. Add slightly more Burnt Sienna to your warm brown mix. Using the same wet-on-dry technique, add texture to the left side of the cone with your medium round brush.

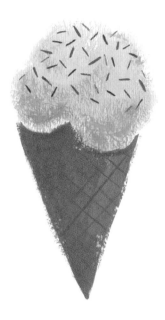

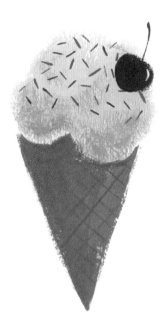

04

Using the darker warm brown mix and a small round brush, paint crisscross diagonal lines on the cone. You may want to add more water at this point to make the paint easier to handle.

Using your small round brush, paint sprinkles on the ice cream. I used Yellow Ochre, Primary Blue, Flame Red, and Permanent Green Middle. Make sure you vary the angle of each sprinkle so it looks like they have fallen naturally. Remember to wash your brush each time you change colors.

05

Mix Spectrum Red with a small amount of Lamp Black to create a dark red. With your small round brush, paint a cherry, including the stem, on the ice cream. When the paint is dry, use your small brush and Permanent White to add a spot of light reflecting on the right side of the cherry.

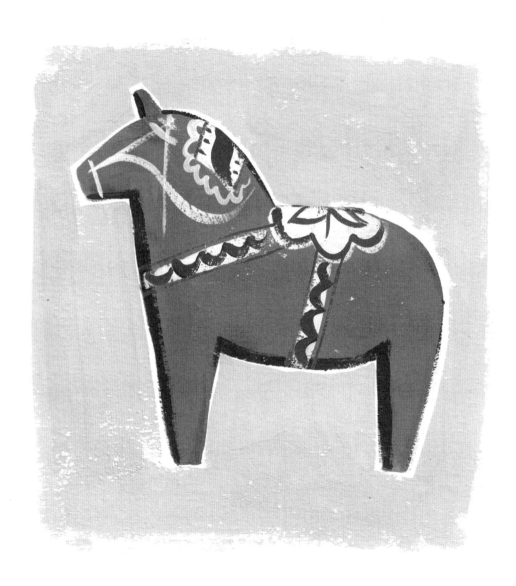

Painting Light on Dark: Swedish Dala Horse

My wooden Swedish Dala horse was the inspiration for this painting. The traditional Swedish Dala horse has an iconic stocky shape and hand-painted decoration. This painting uses light paint over dark to capture the decorative details. We also use different tones of the same color to add definition and shading and to create a textured background. This piece also uses a very limited color palette, just red and green plus black and white.

There are many different background colors that can work in this picture, for example a pale sky blue (Ultramarine and Permanent White) or a minty green (Permanent Green Middle and Permanent White). I have gone for a pale pink because I love the combination of red and pink.

TOOLS & MATERIALS

Red pencil

Medium round brush

Small round brush

Large angled brush

COLORS

Flame Red

Permanent White

Permanent Green Middle

Lamp Black

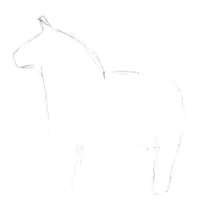

01

Using a red pencil, start by sketching out the shape of the Dala horse, using my sketch as reference. I have chosen a red pencil to match the color of the painting so the lines won't be visible once they are painted over. If you don't have a red pencil, you can very lightly sketch with a regular graphite pencil, but make sure you keep the lines as light as possible. Pencil lines can sometimes show through the paint if they are very dark.

TOP TIP

Because you are painting a large area, make sure you have mixed up enough paint. It can be difficult to match the color if you run out halfway through. Fill at least half the well in your palette with paint. It's better to have too much than too little.

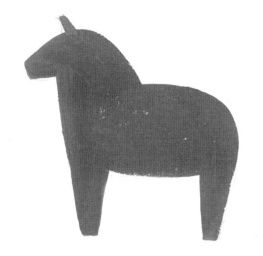

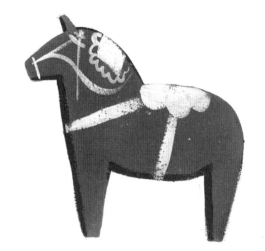

02

Mix together two-thirds Flame Red with one-third Permanent White and a small amount of water. How much water you need will depend on the consistency of the paint as it comes out of the tube. You want the paint wet enough to be able to get fine details, but not so wet that it is translucent. Paint a little test swatch on a spare piece of paper to check the consistency and color. Then, using a medium round brush, paint the horse with smooth directional brushstrokes. (For example, use one or two long vertical brush strokes to paint the legs, rather than multiple horizontal brushstrokes.) The finish you are going for should be fairly neat with a small amount of texture.

03

When that layer is dry, use a small round brush to add shadow to the horse with pure Flame Red. Add shadow to the left-hand side of his legs, his underside, ear, and head. If you are struggling to paint these lines smoothly, add a small amount of water to the paint. When that's dry, add the white details to the horse. Use the small round brush and Permanent White paint straight from the tube so that the paint appears textured when brushed onto the horse. Adding water will reduce the opacity of the white paint and the texture created, so add water only if the paint is very dry and difficult to use. Apply curved brushstrokes to the horse's face and side, use circles for the saddle, and brush on broad lines for the harness and straps. Paint a rough square on the back of the horse's neck and then carefully add the pattern around it using the tip of your brush.

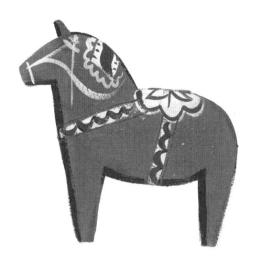

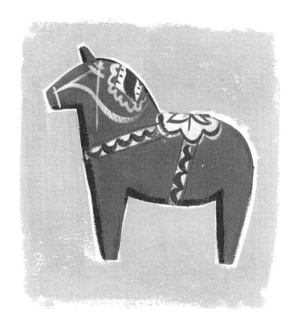

04

Once the white paint is dry, mix Permanent Green Middle with a tiny amount of Lamp Black and a tiny amount of Permanent White. It may seem odd to add both black and white to the same color, but rather than canceling each other out they perform different functions. The white lightens the green, whereas the black makes it cooler and more muted because of its blue undertones. Paint a small swatch on a spare piece of paper to check that you like the color. Use your small brush to add details to the horse as shown.

05

The next step is to paint the background. Add a small dab of Flame Red to a large quantity of Permanent White. You will need less red than you think. Remember that light colors often dry darker on the paper. Paint a test swatch first before painting the background. Using a large angled brush, start by painting the area closest to the horse's body first, painting broad directional strokes following the contour of its legs and back. Add more paint to build up the background, creating a rough square (or rectangular) shape. Keep the edges of the square rough with lots of texture. Turn the paper round as you work so you don't smudge the wet paint and your brush-strokes can flow smoothly.

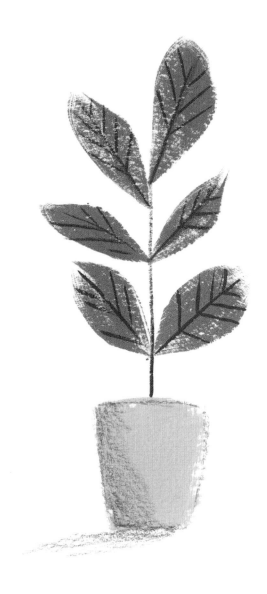

Using Square and Angled Brushes: Potted Plant

Don't be deceived by the simplicity of the potted plant you see here. By using square and angled brushes, you can create a piece full of textures. If you've previously only painted with round brushes, it can feel a little bit different, but these brushes are great fun to work with, and I find the finished result really effective.

It can take a little while to get used to using these brushes, but it's worth persisting with because it will improve your brush control. A round brush can be picked up and used from any side but a square or angled brush will create very different effects depending which side you're using.

TOOLS & MATERIALS

Medium square brush

Small round brush

Medium angled brush

Peach/red pencil

Gray/dark brown pencil

COLORS

Permanent White

Flame Red

Burnt Umber

Permanent Green Middle

Yellow Ochre

TOP TIP

If you accidentally smudge some paint, you can often remove it if you act quickly. Using a clean brush dipped in clean water, carefully wash the area, then blot with a tissue or paper napkin. This should remove the paint from the paper. Wait until the paper is completely dry before continuing. This works best on small smudges, not large areas.

01

Mix together Permanent White with a little bit of Flame Red and a very small amount of water. Using a medium square brush, paint a simple rectangle, slightly wider at the top than the bottom. It should take only a couple of brushstrokes. You should also see a little bit of texture around the edges. Using a small round brush and Burnt Umber straight from the tube, paint the stem of the plant to be as thin as possible. I have used the paint quite dry so that the line is broken up with texture.

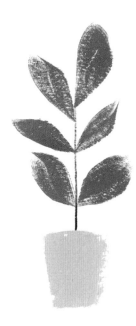

02

Create a mixture of Permanent White, Permanent Green Middle, and Yellow Ochre. The gouache should be quite thick, so add only a few drops of water to it. Creating the shapes for these leaves using an angled brush can take a bit of practice, so I recommend having a few goes at this brushstroke on a separate piece of paper before working on the final piece. With a medium angled brush, pick up some paint and place the point against the stem to begin painting the leaves.

Gently apply pressure and gradually lift the brush up, pulling it away from the stem and leaving a textured brushstroke behind. Place the point of the brush on the same place on the stem and repeat the motion rounding off the bottom of the leaf. Continue painting leaves in this way, turning the paper as you work, if necessary, until you have painted six leaves, three on each side of the plant.

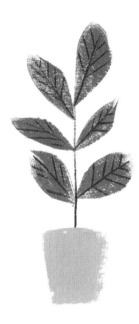

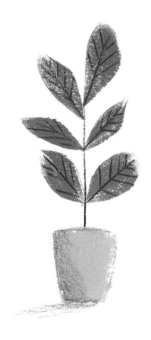

03

When those leaves are dry, create a mixture of Permanent Green Middle, Burnt Umber, and a small amount of water. Using your small round brush, paint veins on the leaves.

04

Using either a peach or a red pencil, add some shading to the left side of the plant pot to add definition. With either a gray or dark brown pencil, add some shadow underneath the plant pot to give a sense that it is sitting on the ground.

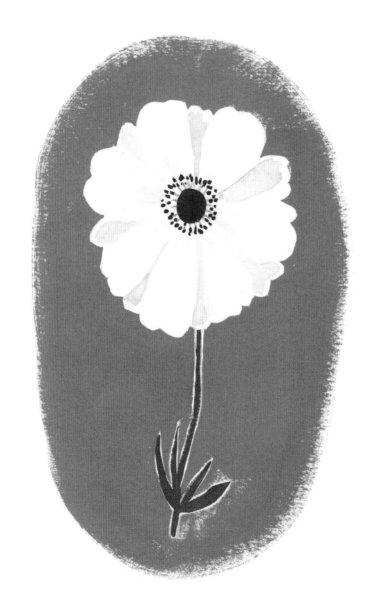

GET STARTED WITH GOUACHE

Diluting Gouache: White Anemone

Varying tones and textures can be created when you dilute gouache. By adding lots of water to gouache, you produce a thin paint very similar to watercolor, which can be used to create delicate shadows. This contrasts with the bold-textured background in this piece. Note how this piece also makes use of negative space.

TOOLS & MATERIALS

Graphite pencil

Medium round brush

Eraser

Small round brush

Black pencil

COLORS

Spectrum Red

Lamp Black

Permanent White

Permanent Green Middle

01

Very lightly sketch an anemone, using a graphite pencil and my drawing as a reference.

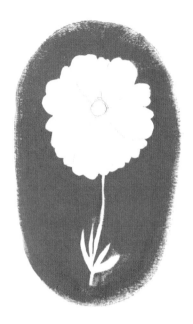

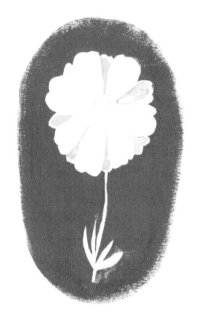

02

Create a deep purple mixture from Spectrum Red with a small amount of Lamp Black and Permanent White. Paint a test swatch, wait for it to dry, and adjust the color, if necessary. Using a medium round brush, paint carefully around the flower. Paint the area next to the flower first with lots of paint on your brush to get neat crisp lines. Once that area is painted, use a dryer brush to paint out toward the edges, creating texture and filling out the shape into an oval. If you struggle with creating texture, lightly brush over the edges of the oval with a drier mixture of paint on your brush to soften the edges.

03

Once the background paint is dry, erase any remaining pencil marks. To add shadows to the petals, mix a tiny bit of the original deep purple with more black and then add lots of water until it's very diluted. Paint a test swatch to check the consistency and color. You want it to be very pale. Using a small round brush, carefully paint in some shadows on the back petals and small strokes on the front petals.

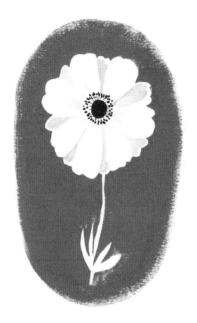

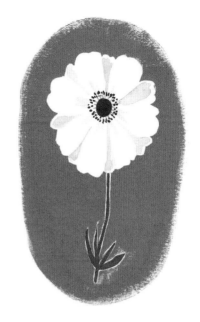

04

Using your small brush and Lamp Black, paint a circle for the center. Using a black pencil, draw thin lines coming out from the center to represent the stamens. With your small brush and black paint, add little dots to the end of each line.

05

Mix a small amount of Lamp Black with Permanent Green Middle. Use your small brush to paint the stem and leaves, leaving a small border of white around the edges.

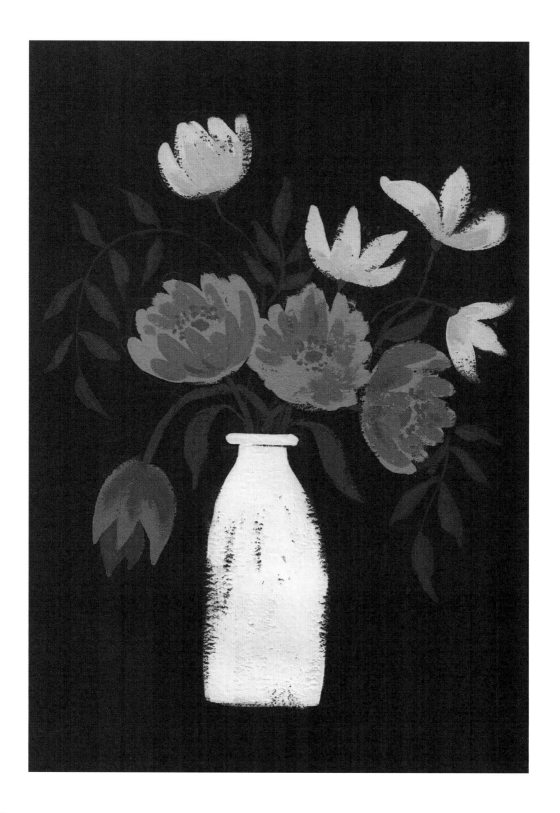

Using Colored Paper: Poppies on a Black Background

The opaque nature of gouache makes it perfect for using on black paper. I recommend using a thick, black card stock. This piece takes inspiration from classic Dutch flower paintings that depict beautiful exotic blooms on dark, moody backgrounds. It's also reminiscent of certain styles of folk art. The raw-textured edges and simple arrangement of flowers make it feel modern and fresh.

TOOLS & MATERIALS

Pencil

Black paper

Medium round brush

Small round brush

Medium square brush

COLORS

Flame Red

Permanent White

Spectrum Red

Primary Yellow

Burnt Umber

Permanent Green Middle

Yellow Ochre

01

Using a pencil and my sketch for a reference, draw a milk bottle with the stems, leaves, and flowers of poppies and tulips onto black paper.

Create a light peach mixture from Flame Red and Permanent White and paint the poppies using a medium round brush. Make sure the paint is thick enough that you can't see the black paper through it and that your brushstrokes have dry, textured edges. Once this layer is dry, add some more Flame Red to the mixture and add more details to the poppies using your medium round brush. This second layer of darker paint should add shadows and give a feeling of depth to the flowers.

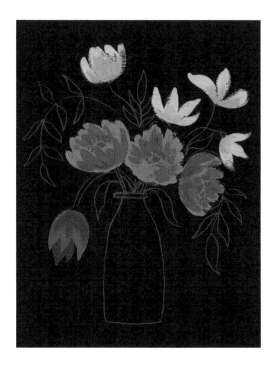

02

On your palette, mix a very pale pink using Permanent White and a small amount of Spectrum Red. In another section of your palette, mix up a pale yellow using Permanent White and Primary Yellow. Using your medium round brush, paint the pale pink flowers. While the pale pink flowers are drying, add pale yellow to the base of the flower where the petals meet the stem, blending the colors with your brush. Pull your brushstroke upward toward the tip of the petal to blend the colors in.

03

Paint the tulips using the leftover peach mixture created for the poppies and your medium round brush. Once it is dry, use Flame Red and your small round brush to add detail, painting the interior of the tulips a shade darker and adding depth to the base of the flower where the petals meet the stem. Create a mixture of Primary Yellow and a small amount of Permanent White, and roughly paint circles in the centers of the poppies using your small round brush. Make a mixture of Primary Yellow, Burnt Umber, and Permanent Green Middle to create a muted yellowy-green. With your small brush, add detail to the center of the poppies.

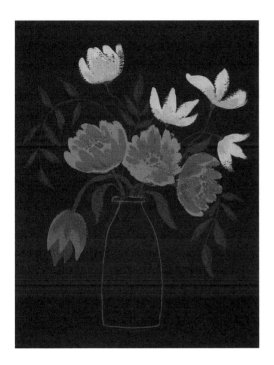

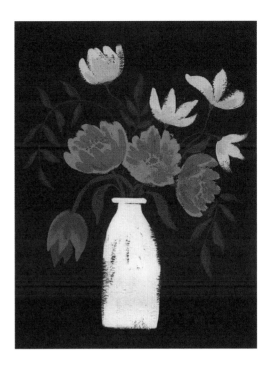

04

Create a dark green mixture by combining Permanent Green Middle with a small amount of Burnt Umber and Spectrum Red. Using your small brush, carefully paint meandering stems. Take your time to get the lines nice and delicate. When the stems are dry, start to paint the leaves with your small brush. Try to make the leaves slightly irregular to make them look more natural; perfectly pointed leaves won't look real. Add Yellow Ochre to the green mixture to lighten it. Use this with your small brush to paint the stem of the tulips and the larger leaves and to add highlights to the smaller leaves.

05

With a medium square brush, apply Permanent White to the milk bottle using broad, vertical brushstrokes. Keep the paint mixture fairly dry so that lots of texture develops and the black paper peeps through in areas. Finish the top and neck of the bottle using your medium round brush—leave a black line between the top and neck to define the shadow there. With your small brush and the green mixture, add small dots around the petals of the pale pink flowers.

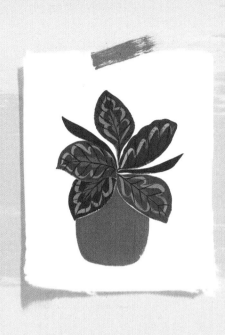
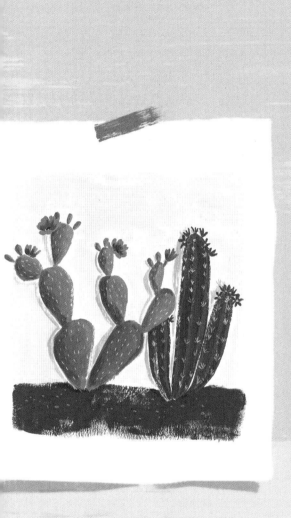

PLANTS AND FLOWERS

Plants and flowers are among my favorite things to paint; there is so much variety in color, shape, and texture. For this chapter, I have taken inspiration from everything, from botanical photos on Instagram to midcentury design to my own collection of houseplants.

GET STARTED WITH GOUACHE

Simple Flowers

These simple flowers can be endlessly adapted with different color palettes and compositions. For this piece I have used varying shades of pink and green. Wet-on-wet and wet-on-dry techniques add definition to the simple flowers. I have sketched with a peach pencil because I don't want the pencil lines to show through the light pink paint that will be used. A red or pink pencil will work, too. If you don't have any colored pencils, you can sketch very lightly with a regular graphite pencil.

TOOLS & MATERIALS

Peach pencil

Small round brush

Medium round brush

Eraser

COLORS

- Flame Red
- Permanent White
- Spectrum Red
- Permanent Green Middle
- Lamp Black
- Yellow Ochre
- Burnt Umber

01
With a peach pencil, lightly sketch a variety of flowers and leaves, using my sketch as a reference.

02

Create a mixture of Flame Red, Permanent White, and water. Using a small round brush, paint one of the small flowers. Add some more white to the mixture, and continue using your small round brush to paint the other two small flowers. Using the same mixture and a medium round brush, paint the large fan-shaped flower.

03

Create a pale mixture of Spectrum Red, Permanent White, and water. Remember that colors often dry darker than they appear on the palette, so don't use too much red. You can paint a test swatch on another piece of paper first to check the color. Using your medium round brush, paint the flower shaped like an umbrella and the round flower. I've painted the round flower second with a slightly dryer brush, to give more texture. Add more white and water to the pale pink mixture to make a more watery mixture that stays wet on the paper for longer. Paint the remaining flower.

Make a pale green mixture out of Permanent Green Middle, Permanent White, and some water. Using your small round brush, paint a circle of pale green onto the pink flower you've just painted. The paint will still be wet, so the green and pink should blend slightly.

04

Use the pale green mixture and small round brush to paint some of the leaves. Create a more muted green mixture using Permanent Green Middle, Permanent White, and a tiny bit of Lamp Black. The blue undertones in Lamp Black make this green cooler and more muted. With your small round brush, paint more of the leaves.

Mix together Permanent Green Middle, Yellow Ochre, and a small amount of water to create a dark green. Using your small brush, paint the remaining leaves.

05

Create a dry mixture of Permanent White and Spectrum Red; don't add any water to the mix. Use this mixture to paint petals on the round flower using your small paintbrush. Paint large sweeping brushstrokes at the edge of the flower and use smaller round brushstrokes toward the center. The dry paint mixture should give a broken, textured look to the brushstrokes.

Add more Spectrum Red and some water to the mixture. Using your medium round brush, paint petals on the lower half of the umbrella-shaped flower, to give the sense that the flower is open and some petals are in shadow.

Create a mixture of Flame Red, Permanent White, and a small amount of water and paint the petals at the bottom of the fan-shaped flower using your medium round brush. Using the peach pencil, lightly draw in petals on the ranunculus (the green-and-pink flower).

06

Create a dark green mixture using Permanent Green Middle, Burnt Umber, and a small amount of water. Using your small brush, paint the stems and veins on the pale green and dark green leaves. Create another dark green mixture using Permanent Green Middle, Lamp Black, and a small amount of water. Using your small round brush, paint the stems and veins on the muted green leaves.

07

Mix Lamp Black with a bit of water. Using your small brush, paint the centers in the small flowers. Paint a large round center with small dots around it on the umbrella-shaped flower, which should now resemble a poppy. Paint stamens (thin lines and dots) on the fan-shaped flower. Once everything is dry, carefully erase any remaining peach pencil marks around the edges.

TOP TIP

Colored pencils are very useful for adding details and texture. Here, I have used a peach pencil to add petals to the ranunculus. You could also use a dark green pencil to add veins to the leaves if you find painting thin lines tricky.

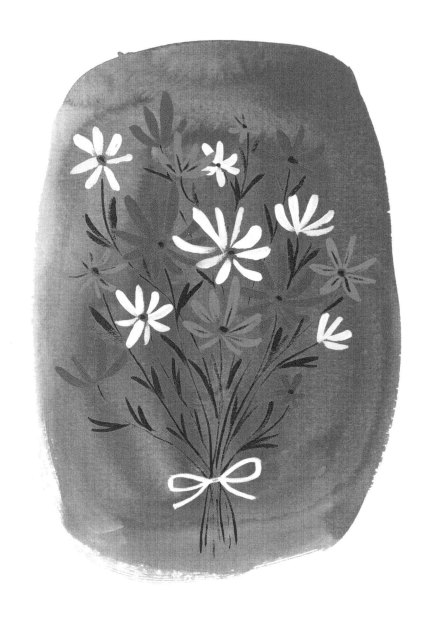

GET STARTED WITH GOUACHE

Wildflowers

This piece explores the use of diluted gouache and a limited color palette. You will create contrast by layering thicker paint on top of a background of the same color. There are endless ways to adapt this simple exercise using whatever color palette you fancy.

TOOLS & MATERIALS

Large square brush

Small round brush

Pencil (optional)

COLORS

Yellow Ochre

Permanent White

Flame Red

Lamp Black

Permanent Green Middle

01

Mix plenty of water into some Yellow Ochre to create the consistency of watercolor paint. Paint a large rough oval using a large square brush. You want the paint to be translucent and uneven in areas.

02

When this first layer is completely dry—it will take a little while because the paint is so wet— paint some flowers using a much thicker mixture of yellow ochre and a small round brush. Notice how different the yellow ochre looks with less water. Don't worry about making the flowers too perfect; these are wildflowers so it's okay if they're all a little bit different.

03

Once those flowers are dry, mix some Permanent White with water, adding the water carefully so that the gouache is thin enough that you can control it, but not so thin that the background shows through. With your small brush, paint some flowers with the white.

Create a mixture of Flame Red and white with a small amount of water and paint some more flowers with your small brush.

04

Mix a tiny bit of Lamp Black with Yellow Ochre and paint centers in all of the flowers with your small brush. Paint thin lines along some of the yellow flower petals. Using Flame Red straight from the tube and your small brush, paint thin lines along some of the pink flower petals.

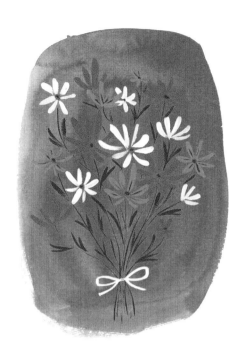

05

Mix up a dark green color using Permanent Green Middle and Lamp Black and a bit of water to make paint for the stems and leaves. If you like, sketch the stems first in pencil to get them in the right place. Using your small round brush, paint the stems and leaves. Don't rush these; try to get the stems as thin as possible. Using this green and your small brush, add a small dot to the centers of the open flowers.

With your small brush, carefully paint a white string around the flowers. Again, you will need to carefully balance the amount of water you add to the Permanent White so that it is opaque enough to stand out against the background, but thin enough to create fine details.

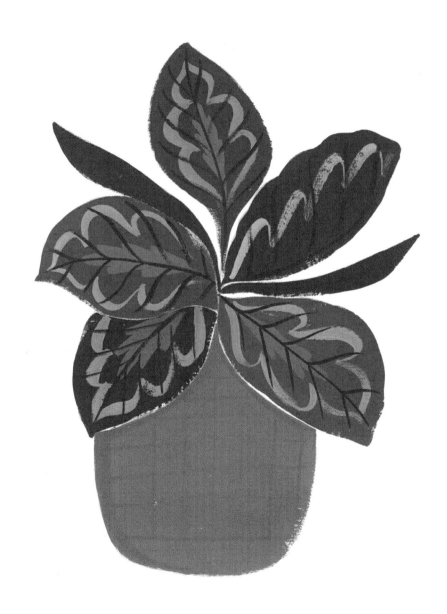

Calathea in a Pot

Calatheas are one of my favorite houseplants. They are known for their beautiful variegated leaves, which have a graphic, decorative quality. In this piece, we will be using opposite colors red and green to capture the rich tones of the leaves, and light on dark to capture the beautiful patterns. The pot is a muted yellow, which complements the rich tones of the plant.

TOOLS & MATERIALS

Pencil

Medium round brush

Large round brush

Eraser

Small round brush

COLORS

Permanent Green Middle

Spectrum Red

Permanent White

Primary Yellow

Yellow Ochre

Lamp Black

01

With a pencil, start by lightly sketching the plant and pot, using my drawing as a reference. Some of the leaves should be turned toward you, and others should be slightly angled away; these will appear much more narrow.

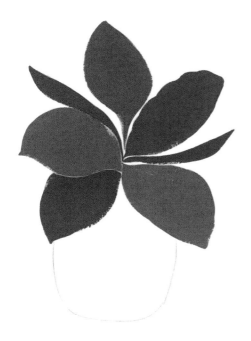

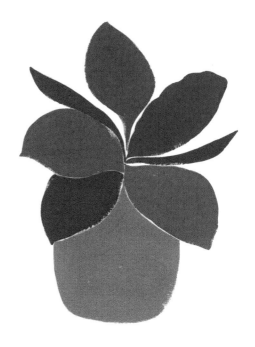

02

Create a deep green mixture using Permanent Green Middle, a little bit of Spectrum Red, a little bit of Permanent White, and a little bit of water. Paint a couple of the leaves using a medium round brush. Add a tiny bit more Permanent White and then paint a few more of the leaves. This adds a nice variation in tone to the leaves.

Make a mixture of Spectrum Red with a small amount of Permanent Green Middle and Permanent White to create a very deep purple. Use this purple and your medium round brush to paint the remaining leaf.

TOP TIP

Turn the paper round while you work, so you're always pulling the brush toward you at an angle that's comfortable. It will help your lines flow more smoothly.

03

Create a muted yellow mixture with Primary Yellow, Yellow Ochre, Permanent White, a tiny bit of Lamp Black, and some water. Using a large round brush, paint the plant pot. When the paint is completely dry, remove any excess pencil lines using an eraser.

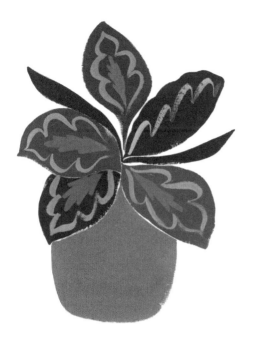
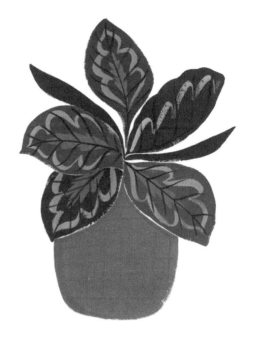

04

Lighten the green mixture on your palette by adding more Permanent White and water. With a small round brush, add detail to the center of the green leaves. Add a bit more white to the green mixture and, using your small brush, paint the curved lines around the outside of each leaf. Add white and a little bit of water to the purple mixture until a light purple is achieved. Using your small brush, paint curved lines on one side of the purple leaf.

05

To produce a very dark green mixture, combine Permanent Green Middle, a little bit of Spectrum Red, and a small amount of water. Use this green and your small brush to paint veins on the leaves. Paint the central line first, then the veins branching out. Take this slowly and try to make the veins as delicate as possible.

Add some Lamp Black and a small amount of water to the yellow mixture, creating a deeper yellow. Using your small brush, add shadow to the side of the plant pot and under the leaves. Paint a crisscross pattern on the pot.

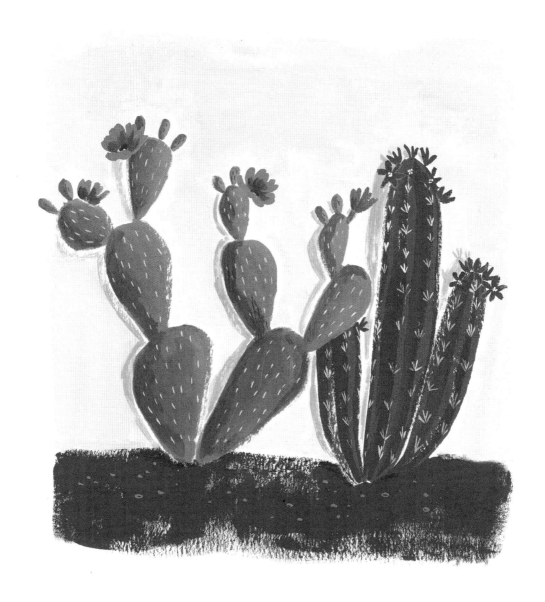

Cacti against a Pink Wall

Certain color combinations are matches made in heaven—pink and green is definitely one of them. Vivid green cacti contrast against a soft pink wall. You will use a variety of techniques, from wet-on-wet to dry brush, to build up texture and depth in this piece.

TOOLS & MATERIALS

Graphite pencil

Medium round brush

Small round brush

Eraser

Medium angled brush

Dark brown pencil

COLORS

Permanent Green Middle

Spectrum Red

Permanent White

Permanent Yellow Deep

Burnt Umber

Flame Red

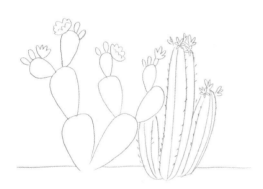

01

Begin by lightly sketching two cacti, using a graphite pencil and my sketch to guide you. First, sketch a light horizontal line to indicate the ground. Next, add the largest section of the cactus, then the smaller sections, finishing with the flowers or prickly pears.

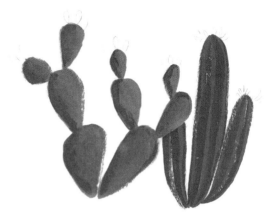

02

Mix together Permanent Green Middle with a little bit of Spectrum Red and Permanent White, and a little bit of water. Using a medium round brush, scoop half of the green mixture into another well on your palette and add a little bit more Permanent White to make it lighter. Paint the cactus on the left with your medium round brush, starting with the dark shade, then adding some of the lighter green paint mix and blending it in. Carry on with this method until all the sections of this cactus are painted.

03

Create a mixture of Permanent Green Middle, Permanent Yellow Deep, a little bit of Permanent White, and some water. Using the same method as before, transfer half the green into another well on your palette and add some more white to create a lighter shade of green. Using a small round brush, paint the cactus on the right in alternating stripes of lighter and darker green.

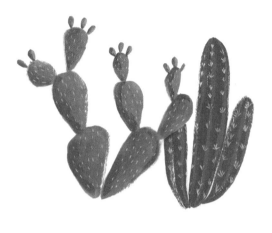

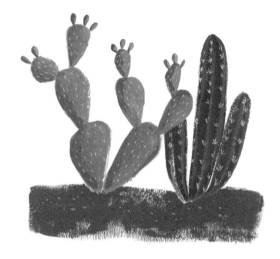

04

Using your small round brush and Permanent White, paint small dashes to indicate spines on the cacti.

Create a dark pink mixture using Spectrum Red, a tiny bit of Permanent Green Middle, and a tiny bit of Permanent White and paint the prickly pears on the cactus on the left. Mix up a darker version of the pink color by adding more Spectrum Red and use your small brush to add shadows. When the paint is completely dry, erase any remaining pencil marks.

05

Mix Burnt Umber with Permanent White to create a dark brown. Paint the ground using a medium angled brush in broad dry brushstrokes to create lots of texture.

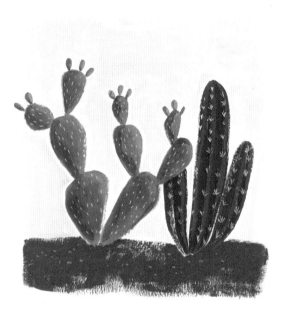

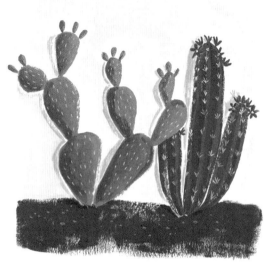

06

For the background, mix up lots of Permanent White with a little bit of Spectrum Red and some water to create a pale pink. Fill in the background using your angled brush for the larger areas and your small and medium round brushes to fill in the smaller gaps in between the cacti. Leave the edges rough and don't worry about some white space between the edges of the cacti and the background.

07

Use your small brush and some Flame Red to add flowers to the cactus. When they are dry, use your small brush and Permanent White to add small dots to the centers of the flowers. Use a dark brown pencil to add shadow and texture to both cacti and add small dashes to the prickly pears. Add a small amount of Spectrum Red to the pale pink mixture and, using your small round brush, paint in shadows behind the cacti.

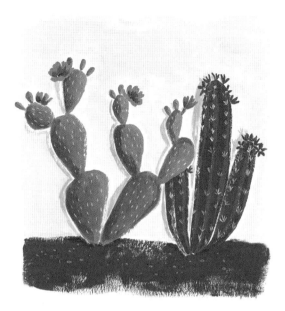

08

Add flowers to the prickly pears. Create a dark pink mixture using Spectrum Red and Permanent White and a little bit of water. Using your small brush, paint large open flowers on the prickly pear. Add more Spectrum Red to the flower centers. When that layer is dry, use your small brush and Permanent Yellow Deep to paint the centers.

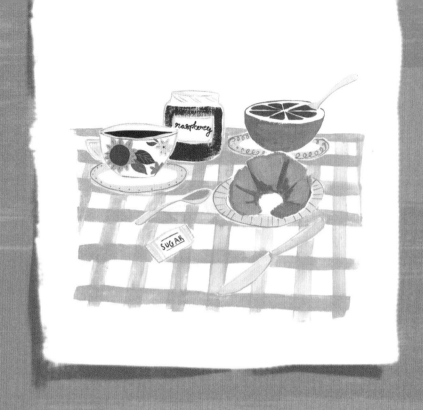

FOOD

Food is a great subject for a painting; it's part of our everyday lives and easily accessible. I recommend starting by painting fruit and vegetables because they offer a huge range of colors, shapes, and textures. Capturing the browns and beiges of our favorite foods, such as croissants, and making them look appealing is slightly more tricky. Once you get the hang of painting food on its own, you can use your skill to set up still lifes in your home to sketch from, something artists have been doing for hundreds of years.

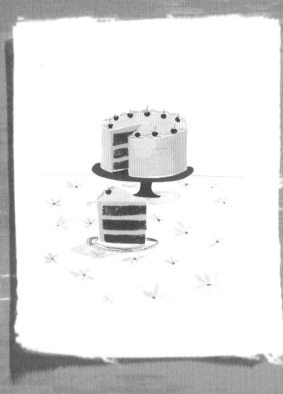

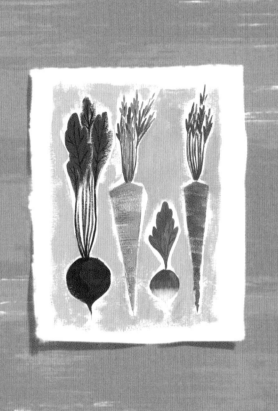

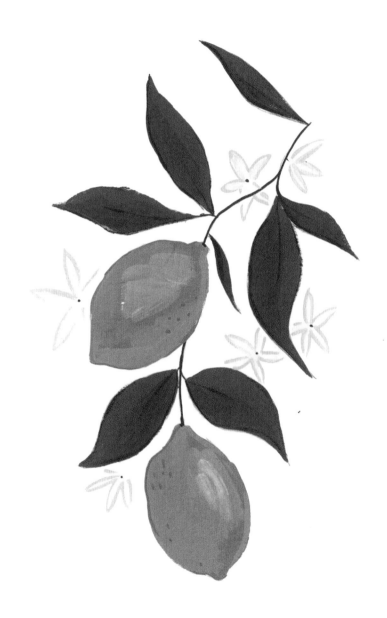

GET STARTED WITH GOUACHE

Lemons

These gorgeous lemons were inspired by a trip to Mallorca in the springtime. The whole island was full of lemon groves, and the scent of the blossoms was everywhere. In this piece, you will be using the wet-on-wet technique to add depth to the lemons and the leaves. It's important that the highlights and the shadows are both added while the base coat of yellow is still wet, which is why I suggest working on one lemon at a time. Adding extra water to the paint mixes keeps them wet on the page for longer and allows you to blend the colors on the paper.

TOOLS & MATERIALS

Pencil

Medium round brush

Small round brush

Eraser

COLORS

🟨 Primary Yellow

⬜ Permanent White

🟫 Burnt Umber

🟩 Permanent Green Middle

🟨 Yellow Ochre

🟥 Flame Red

01

With a pencil, roughly sketch the lemons, leaves, and flowers, using my drawing as a reference.

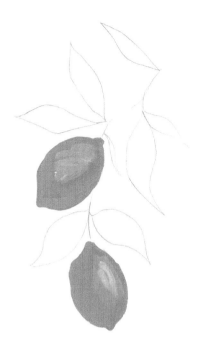

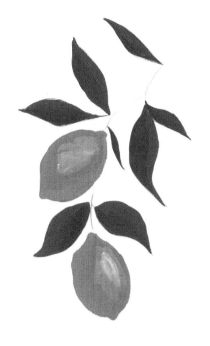

02

Combine Primary Yellow, Permanent White, a tiny bit of Burnt Umber, and plenty of water to create a pale yellow mixture. Paint the first lemon using a medium round brush. While the first coat is still wet, add a tiny bit more Burnt Umber to the yellow mixture and paint some shadows around one edge of the lemon. Squeeze out some Permanent White onto your palette and mix with water. Using a medium round brush, add some white highlights to the lemon. The first coat of yellow should still be wet so the white should blend in, giving a subtle highlight. Repeat the process for the second lemon.

03

Create a leaf green mixture with Permanent Green Middle, Yellow Ochre, and plenty of water. Mix up another, darker green with Permanent Green Middle, Yellow Ochre, Burnt Umber, and water in another well of your palette. Using your medium brush, paint one of the leaves with the lighter green. While the leaf is still wet, paint one side using the darker green mixture with a small round brush. The two shades of green paint should blend together. Carry on with this process, painting all the remaining leaves. If the paint on the palette starts getting a little bit dry, just add some more water and mix it thoroughly.

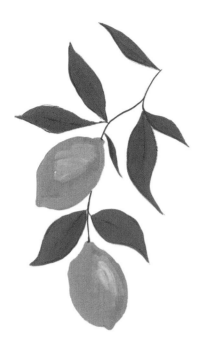

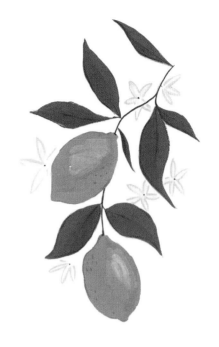

04

Using watered down Burnt Umber and your small brush, carefully paint the stem. Create a mixture of Permanent Green Middle, Burnt Umber, and a tiny bit of water. With your small brush, add detail to the leaves by adding a vein and outlining them. The paint should be quite dry so it adds a bit of texture and leaves the line broken, which keeps it from feeling too heavy.

05

With a mixture of Primary Yellow, Burnt Umber, and water, use your small brush to carefully outline sections of the lemon; again, this is to give some definition without causing it to feel too heavy. Paint on a few dots to show texture. Erase any remaining pencil marks once the paint is completely dry.

Create a pale pink mixture with Permanent White, Flame Red, and water. Using your small brush, paint blossoms dotted around the lemons and leaves. Add more white and more water to the pink mixture, and fill in the petals of the flowers. When they are completely dry, use Burnt Umber and your small brush to paint a center in each flower.

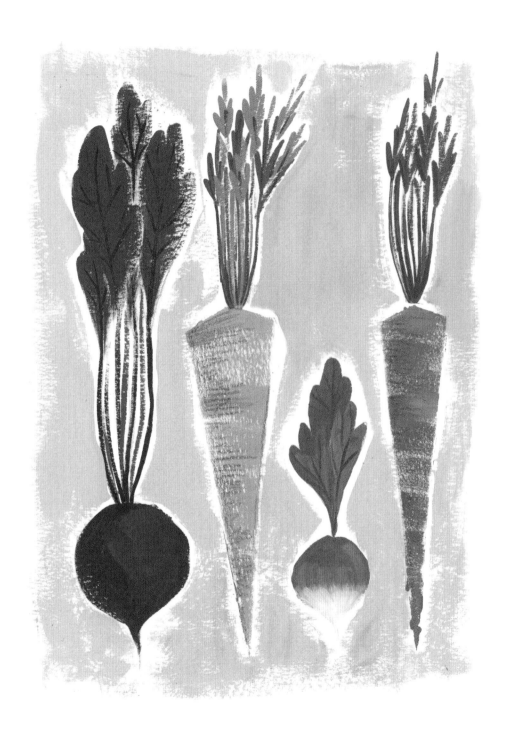

Root Vegetables

Beautiful colors and textures can found in root vegetables. I was struck by their variety and vibrancy when I visited an organic farm in Somerset in southwest England. This piece uses a few different techniques, both wet-on-wet and dry brush, to create a variety of textures.

TOOLS & MATERIALS

Graphite pencil

Masking tape

Eraser

Medium square brush

Medium round brush

Small round brush

Dark brown pencil

Large round brush

COLORS

Permanent White

Yellow Ochre

Permanent Green Middle

Permanent Yellow Deep

Burnt Sienna

Spectrum Red

Lamp Black

Burnt Umber

Flame Red

01

Start by using a graphite pencil to lightly sketch a beet, parsnip, radish, and carrot. Keep the parsnip and carrot very simplified because you are going to use masking tape to paint them. Lay strips of masking tape along the edges of the parsnip and carrot, so a long thin triangle is left in the middle. Make sure the masking tape is firmly attached to the paper. Very carefully erase any pencil marks inside the triangle.

02

Create a parsnip color with a mixture of Permanent White, small amounts of Yellow Ochre and Permanent Green Middle, and a little bit of water. You want the paint mixture fairly dry so that you see lots of texture when it's brushed on. Using a medium square brush, apply the paint in horizontal brushstrokes to a triangle created by the masking tape. Create a carrot color with a mixture of Permanent White, Permanent Yellow Deep, Burnt Sienna, and a small amount of water. Repeat the process for the carrot, using your medium square brush to apply the paint mixture horizontally, leaving visible brushstrokes. Carefully peel off all of the masking tape.

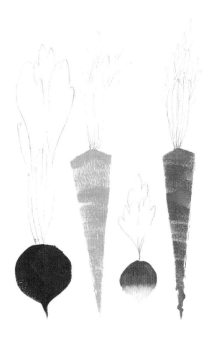

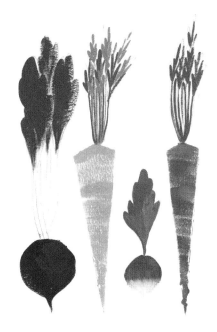

03

While the parsnip and carrot are drying, create a
dark purple mixture for the beet using Spectrum
Red with a small amount of Permanent White,
Lamp Black, and some water. Using a medium
round brush, paint the beet. Add more white to
the dark purple mix. While the paint is still wet,
add the lighter purple to an area of the beet and
blend it in. This gives the beet more of a three-
dimensional shape and adds interest.

Mix Permanent White with plenty of water and
paint the lower half of the radish using a small
round brush. Create a deep pink mixture using
Spectrum Red, Permanent White, and some
water. Use the deep pink mixture and your small
round brush to paint the top half of the radish,
blending the two in the middle.

04

For the beet greens, create a dark green mixture
using Permanent Green Middle, Burnt Umber,
and a tiny bit of water. Use your medium round
brush to paint the greens, creating texture at the
edges. For the parsnip and carrot leaves, create a
light green mixture of Permanent Green Middle,
Yellow Ochre, a small amount of Permanent
White, and water. Use your small round brush to
paint long thin leaves with rough feathery edges
on both the parsnip and carrot. Add more white
to the mixture to lighten it and paint some addi-
tional leaves on the parsnip. Add some more
Permanent Green Middle, Yellow Ochre, and
water to the green mixture and paint the leaves
on the radish with your small round brush. Paint
one leaf and, while it's still wet, add some white
paint to the center, blending it in. Repeat the
process for all three radish leaves.

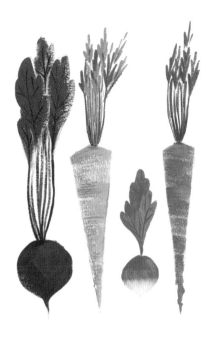

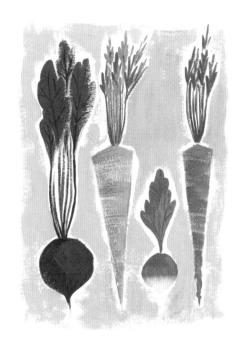

05

Use the remaining dark purple mixture and your small brush to paint stems and veins on the beet greens. Add a small amount of Permanent White to the mixture to paint some additional stems. Using a dark brown pencil, add texture and shadow to the parsnip and carrot. The brown lines are heavier on the left and lighter toward the center, giving the impression of a light source from the right. They also indicate the rough skin of the parsnip and carrot. Create a dark green mixture with Permanent Green Middle and Burnt Umber. Using your small brush, add veins to the radish leaves and paint a few lines on the parsnip stems to add shadow and texture.

06

Once all the paint is dry, erase any remaining pencil marks. For the background, create a pale pink mixture using Permanent White, Flame Red, and a little bit of water. As this color is for the background, make sure you fill the well of your palette. Using a large round brush, roughly fill in the space around the vegetables. I've deliberately painted this very roughly and left lots of white space and texture. The aim is for it not to look too perfect or overworked. You can also use your medium and small round brushes for getting into any difficult areas. Roughly square off the edges with a dry brush and leave lots of texture.

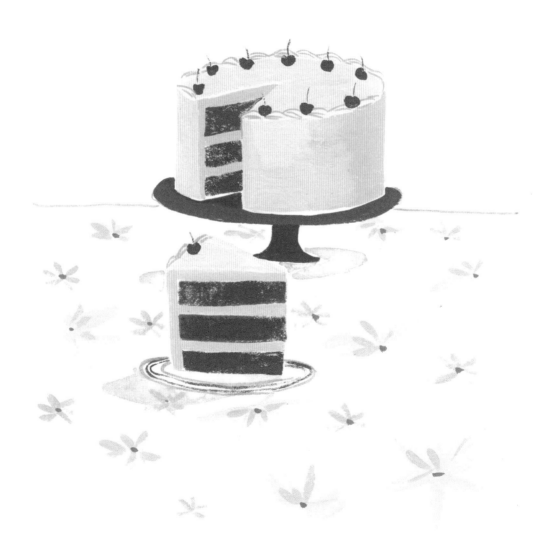

GET STARTED WITH GOUACHE

A Slice of Cake

This simple piece introduces some basic ideas of perspective and making objects look three-dimensional in a fun way. You will find it really easy to adapt the same image to different color palettes; just change the color of the frosting and the pattern of the tablecloth.

TOOLS & MATERIALS

Graphite pencil

Eraser

Small round brush

Dark brown pencil

COLORS

◻ Permanent White

◼ Spectrum Red

◼ Burnt Umber

◼ Lamp Black

◼ Ultramarine

01

Start by using a graphite pencil to sketch two ovals, one above the other. Draw two straight lines down from the left and right edges of the top oval to create a cylinder. Draw a triangle from the edge of the top oval into the center, then draw straight lines down to show where a slice has been cut out. Add additional lines to show where the frosting is, using my drawing as a reference. Draw a larger oval around the bottom oval for the cake stand.

Slightly lower down the page, draw a long triangle. Draw two lines down from two of its corners to create a slice. Draw a small oval around the bottom of this slice to create a plate. Add more lines to show where the frosting is. Using an eraser, rub out the sections of the two original ovals that you don't need anymore.

02

Create a pale pink mixture using Permanent White, Spectrum Red, and some water. Using a small round brush, paint the top and sides of the cake and the slice of cake. Add a tiny bit more Spectrum Red to the paint mix, and paint the frosting inside the cake and add shadow to the right-hand side of the cake. When that's dry, erase any pencil marks around the edges.

03

Make a dark brown mixture of Burnt Umber with a little bit of Permanent White. Using your small brush, paint the inside of the cake. I have used quite a dry mixture to create a bit of texture.

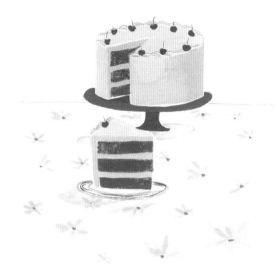

04

Using pure Spectrum Red and your small brush, paint cherries on top of the cake. Make a dark pink mixture with Spectrum Red, Permanent White, and some water. Using your small brush, carefully add wavy lines to show piping on the cake. Create a very watery pale gray mixture with Permanent White and Lamp Black and paint the plate below the slice of the cake, then add a shadow. Add another shadow under the cake stand. Create a dark gray mixture using Lamp Black and Permanent White and paint the cake stand with your small brush. Use a dark brown pencil to draw stems on the cherries. Using Spectrum Red and a small brush, paint two stripes around the edge of the cake plate.

05

Using the watery pale gray mixture and your small brush, paint a line behind the cake stand to indicate the edge of the table.

Create a pale blue mixture using Permanent White and Ultramarine. Use a small brush to paint a pattern of scattered flowers of various sizes on the tablecloth. Don't worry about making the flowers too perfect. To create each flower, drag the tip of the brush toward the center of the flower and then repeat from another angle. Add a tiny bit more Ultramarine to the mix and add some detail in the center of the larger flowers. Use the dark gray mixture from the cake stand and a small brush to add centers to the flowers.

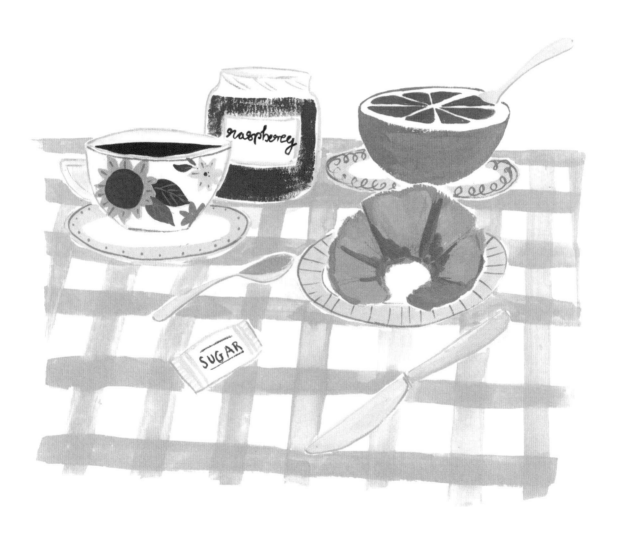

GET STARTED WITH GOUACHE

Continental Breakfast

Inspired by a continental breakfast I once enjoyed, this piece uses food as the subject in a more complex way to create a simple still life. This is the most complex scene yet, combining perspective and overlapping objects. Objects with different textures and patterns create a busy decorative piece.

TOOLS & MATERIALS

Pencil

Small round brush

Medium round brush

Medium angled brush

COLORS

⬜ Permanent White

⬛ Lamp Black

⬤ Ultramarine

⬛ Spectrum Red

⬛ Permanent Yellow Deep

⬛ Flame Red

⬛ Yellow Ochre

⬛ Burnt Umber

01

Start by sketching a continental breakfast scene in pencil, using my drawing as a reference. The image is constructed of many ovals—the plates, the tea cup, the jam jar, the grapefruit. Pay attention to the shape of these ovals. A plate looks like a circle if you view it from directly above and looks like a thin oval if viewed from the side.

Because all the items in the scene are viewed from the same viewpoint, the ovals should be similar in proportions. Think about the angle of the cup and plates and how objects in the forefront of the picture appear slightly larger than those at the back of the picture.

02

Create a pale gray mixture with Permanent White and Lamp Black and a bit of water. Paint the knife blade and teaspoons with a small round brush. Using your small brush, carefully outline the jam jar, the plates, the teacup, and the sugar packet in pale gray. Add more water to the gray mixture until it is very diluted. Use your small brush and the watery gray mixture to add shadows to the left-hand side of the objects and the side of the teacup.

03

Blend Ultramarine and Permanent White to create a pale blue mixture. With a medium round brush, paint the outer rim of the plates. Switch to your small brush and add stripes on the sugar packet and the small flower on the teacup. Add a tiny bit more Ultramarine to the mix and paint the large flower on the teacup using your small brush.

Create a dry mixture of Spectrum Red with a little bit of Permanent White and paint the jam jar using your medium round brush, allowing lots of texture to show. Using the dark pink mixture and your small brush, write the word "sugar" on the sugar packet.

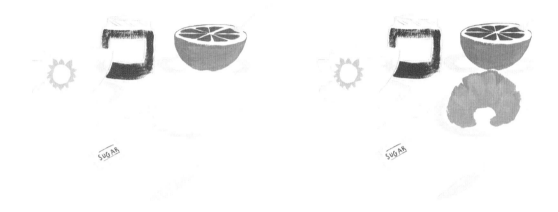

04

Make a pale, peachy orange mixture with Permanent Yellow Deep, Flame Red, Permanent White, and a little bit of water. Using your small brush, paint the outside of the grapefruit. Add a tiny bit more white to the mixture and paint over the right side of the grapefruit while it's wet to add a subtle highlight. Create a deeper pink-orange color using Flame Red and a little bit of Permanent Yellow Deep, Permanent White, and water. With your small brush, carefully paint the segments of the grapefruit, making sure you leave white space in between each one.

05

Create a beige color for the croissant using Yellow Ochre, a tiny bit of Burnt Umber, and Permanent White. Using a medium angled brush, paint the croissant. Start each brushstroke on the outside edge of the croissant and drag it toward the center, leaving dry strokes to resemble flaky pastry. Add a tiny bit more white to the mixture and add highlights in the center to make it look more three-dimensional.

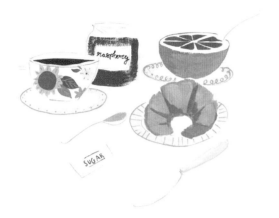

06

Mix a dark blue color using Ultramarine with a little bit of Burnt Umber and Permanent White, and paint the center of the large flower on the teacup and one of the leaves. Add a tiny bit more white to the mixture and paint the second leaf. Create a mixture of Ultramarine, Permanent White, and a bit of water. Using your small brush, add decorative details to the edges of the plates and add a third flower to the teacup. Use this blue mixture to paint veins on the leaves and add lines to the petals.

Make a very pale beige color using Permanent White with a tiny bit of Yellow Ochre and Lamp Black and paint the handle of the knife. Create a mid-toned gray mixture using Permanent White and Lamp Black and outline the edge of the knife and spoons with your small round brush. Using Lamp Black and your small brush, paint the flavor of the jam on the label.

Create a dark beige mixture of Yellow Ochre with a little bit of Burnt Umber, Permanent White, and some water. Using your small brush, paint shadows on the croissant to show layers and to give a sense of it being three-dimensional.

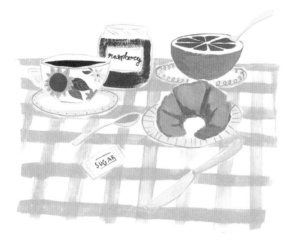

07

Create a pale peach color using Flame Red, Permanent White, and plenty of water. The paint consistency should be thin and semitranslucent. Using the medium angled brush, paint horizontal stripes on the tablecloth under the items, painting over the shadows you painted in the beginning, but carefully painting around the objects. When that is dry, use the same mixture to paint vertical stripes overlapping the horizontal stripes. They should be angled slightly outward toward the edges to give a sense of perspective.

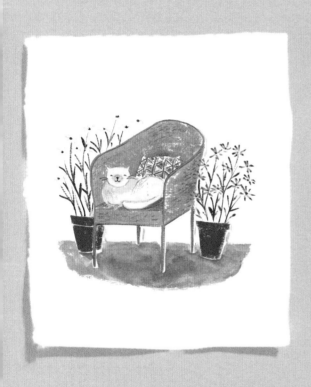
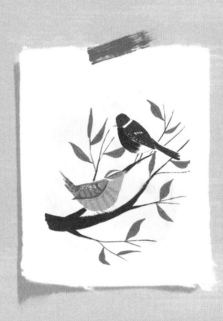
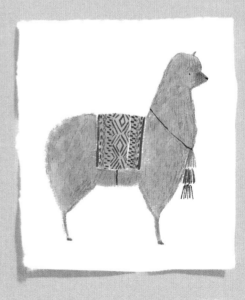

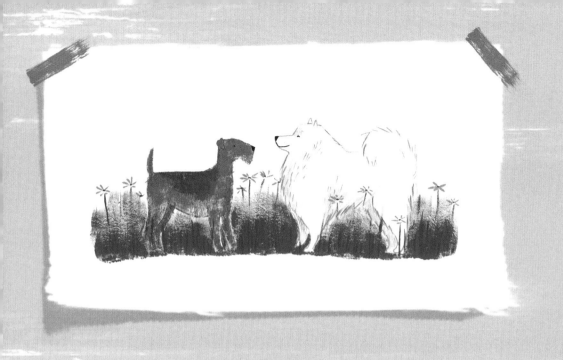

ANIMALS

Gouache lends itself very well to painting animals. In particular, the range of textures that can be created with a gouache is perfect for creating fur, fleece, and feathers. Gouache can be layered up to create depth and detail, and applied with a dry brush to create lots of fluffy texture. This chapter explores painting pets, wildlife, and some more unusual animals. Focus on capturing the personality of the animal you are painting rather than trying to achieve photorealistic results. A trip to your local natural history museum with a sketchbook is a great way to find inspiration and to practice drawing animals.

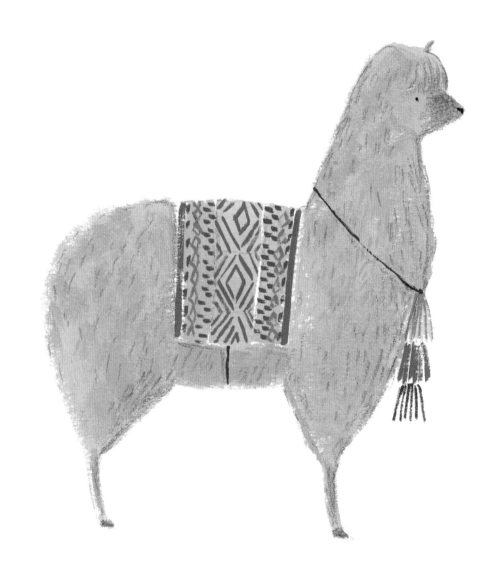

Peruvian Alpaca

While traveling in Peru, I was inspired by the colorfully decorated alpacas I saw. People often get llamas and alpacas mixed up, but the way to tell them apart is alpacas have small ears and lovely fluffy necks, and llamas have a larger ears and skinny necks. This piece combines lots of texture to capture the alpaca's soft fleece and some colorful patterns for its decorative tassels and woven textiles.

TOOLS & MATERIALS
Light brown pencil
Medium angled brush
Small round brush
Tissue

COLORS
⬜ Permanent White
⬛ Burnt Umber
⬛ Yellow Ochre
⬛ Permanent Green Middle
⬛ Spectrum Red
⬛ Flame Red
⬛ Lamp Black

01

With a light brown pencil, lightly sketch an alpaca, using my drawing as reference. The light brown won't show up under the light color of the alpaca's fleece. You will use the same brown pencil to add more texture later on.

02

Create a mixture of Permanent White with a tiny bit of Burnt Umber and Yellow Ochre and a little bit of water. You should have a very pale, beige color. It's a good idea to paint a little test swatch first to check that you're happy with both the color and the consistency of the paint. If the paint looks too dark or too thin, adding a bit more white fixes both problems. Using a medium angled brush, start to fill in the alpaca, leaving the central rectangle blank. Create broad brushstrokes with rough edges that will give the impression of a soft fluffy coat. Paint the legs and ears using a small round brush.

03

Once the alpaca's coat is dry, add a tiny bit more Burnt Umber to the paint mix. Paint shadows around the legs and belly using your medium angled brush. Take any excess paint off the brush using a tissue, then use the dry brush to add texture to the rest of the alpaca. Less is more; it's better to gradually build up texture than to go straight in with paint that is too wet or too dark. Use your small round brush and the paint mixture to paint the alpaca's nose, and to paint little dashes over in the fleece to add texture.

04

Mix up a pale green color using Permanent White, Permanent Green Middle, and a tiny bit of Spectrum Red. With your small round brush, paint a central stripe down the center of the fabric on the alpaca's back. Use the same color and your small brush to paint the first tassel hanging from its neck. Mix up a pale peach color using Permanent White and Flame Red and paint two stripes on either side of the green stripe using your small round brush.

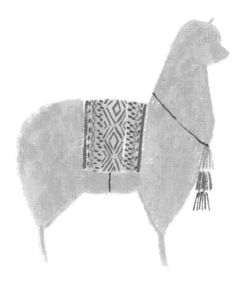 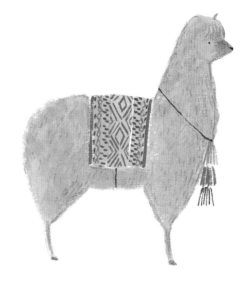

05

Create a dark pink mixture of Permanent White and Spectrum Red, and paint a diamond pattern on the pale green stripe using your small round brush. Paint two stripes at the edges of the fabric, and paint the second tassel pink. Make a darker peach color with Flame Red and Permanent White and paint alternating dashes on the pale peach sections of the fabric.

Create a green mixture using Permanent Green Middle and a small amount of Permanent White and paint small diamonds on the peach section of the fabric. Use Permanent Green Middle and your small brush to paint the last tassel. Use Flame Red and your small brush to add strings around the alpaca's neck and belly.

06

Using your light brown pencil, add more texture to the alpaca's fleece and to further define its features. Add little dashes all over and shadows around its legs, belly, and neck. Color in its hooves and nose.

With a small brush and Lamp Black add a nose and an eye.

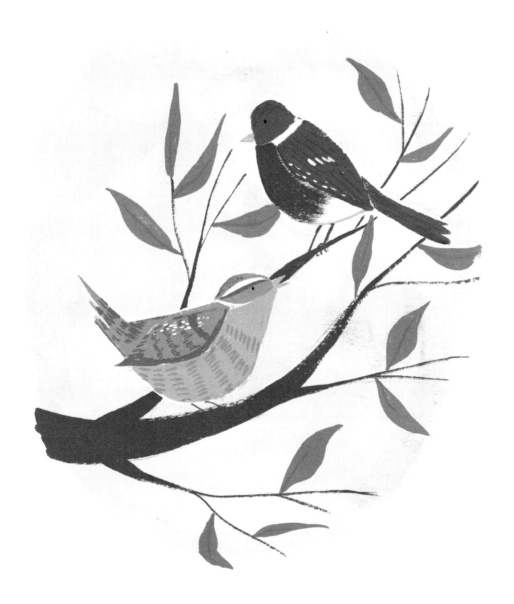

Birds on a Branch

This piece is inspired by the wild birds you might see in your garden, capturing nature with subtle muted tones. The color palette evokes the feeling of a blustery winter's day. The two birds give you the opportunity to create the appearance of feathers using a variety of brushstrokes.

TOOLS & MATERIALS

Pencil

Medium round brush

Small round brush

COLORS

Permanent White

Lamp Black

Permanent Yellow Deep

Flame Red

Burnt Umber

Primary Yellow

01

Start by using a pencil to very lightly sketch two birds on tree branches, using my drawing as a reference. First sketch a thick branch with thinner branches coming off it, then add the bodies of the two birds, the one on the left shaped like a semicircle and the one on the right shaped like a pear. Next add thin legs connecting them to the branches, as well as wings, tail feathers, and triangular beaks.

02

Mix Permanent White with a little bit of Lamp Black, Permanent Yellow Deep, and water to create a pale yellowy gray color. Paint the underside of the bird on the left using a medium round brush. Create a muted red with a mixture of Flame Red with a little bit of Lamp Black, Permanent White, and water. Paint the chest of the bird on the right with a small round brush. Start your brushstrokes at the neck of the bird and finish them toward the belly, ending each brushstroke with a dry, feathery finish.

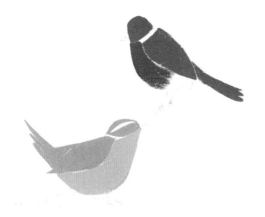

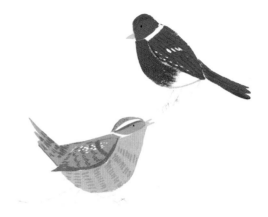

03

Create a cool brown color using Burnt Umber with a little bit of Permanent White and Lamp Black and some water. Take your time getting this subtle color right and remember to paint a test swatch before painting the final piece. It's always easier to adjust the color while it's still on the palette than when it's on the paper. Paint the wing, tail, and head of the bird on the left, leaving a white stripe on its head. Create a darker color with Burnt Umber, slightly more Lamp Black, and a little bit of Permanent White. This color should be a warm dark gray. Using your small round brush, paint the head, wing, and tail of the bird on the right, leaving a white stripe by its neck.

04

Add a tiny bit more Burnt Umber and Lamp Black to the first brown you mixed. Using your small round brush, add details to the bird on the left, such as dashes on its wings and tail to indicate feathers and a second stripe under the white stripe on its head. Add a little bit more Lamp Black to the yellowy gray color you mixed to make it darker, and paint dashes on the bird's chest and underside. Mix up a light gray color using Permanent White and Lamp Black and paint both birds' beaks and an outline to the underside of the bird on the right. Add more black to the mixture and paint lines on the wing and tail of the bird on the right. Then use your small brush to paint dashes on the bird's wings with Permanent White. Add a tiny bit of black to the muted red mixture and paint feathers on the bird's chest.

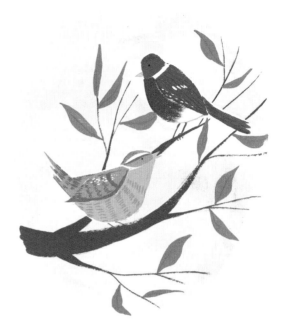

05

Create a very pale gray color using a tiny bit of Lamp Black, a tiny bit of Primary Yellow, lots of Permanent White, and lots of water for the background. It should be very watered down and pale; paint a test swatch first to check it's the right color and consistency. Use your medium round brush to paint the background in a rough oval. Paint around the birds, leaving some white space between them and the background, but paint straight over the pencil lines for the branches. The paint should be thin enough that you see the pencil lines through the color.

06

Mix Burnt Umber with a little bit of Permanent White and paint the branches of the tree using your small round brush. Create a green mixture using Primary Yellow, a tiny bit of Lamp Black and Permanent White, and a little bit of water. Use this to paint leaves with your small round brush. Vary the angle and size of the leaves, making sure they don't look too perfect. Add a tiny bit more black to the green mixture and paint a central vein on each leaf with your small round brush.

Dogs

The skills learned painting these dogs can be transferred to painting any four-legged animal. I have picked a Welsh terrier and a Samoyed due to the contrast in their coloring. The Welsh terrier has a short, curly, brown and black coat, whereas the Samoyed has a fluffy, pure white coat; both require different gouache techniques to capture.

TOOLS & MATERIALS

Pencil

Medium angled brush

Small round brush

Eraser

COLORS

Burnt Sienna

Permanent White

Burnt Umber

Lamp Black

Primary Yellow

Flame Red

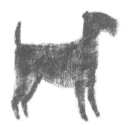

01

Start by sketching the two dogs in pencil, using my drawing as a reference. Sketch the bodies first, which will be a trapezoid wider on one side than on the other. Sketch the back with a horizontal line, the undercarriage as a diagonal line sloping downward toward the chest, then two vertical connecting lines for the front and the back. The legs should be wider at the top than bottom, particularly the back legs. The Welsh terrier has a more straight, upright tail and neck. The Samoyed has a much more angled neck and rounded tail and chest due to its fur. Once you've got the shape of the bodies, add the noses, eyes, and ears.

02

Mix a pale brown color using Burnt Sienna, Permanent White, and a little bit of Burnt Umber. Keep the mixture quite dry. Use a medium angled brush to paint the body of the Welsh terrier. Use a small round brush to paint the legs, tail, and head. Make short, light, dabbing brushstrokes to create the texture of short curly fur.

Make a pale, warm gray mixture using Permanent White with a tiny bit of Lamp Black and Burnt Umber and lots of water. Use your medium angled brush to paint in a shadow around the Samoyed's head, chest, undercarriage, and legs. Use a small round brush to outline the rest of the dog, using broken lines to indicate long fur for the tail, chest, and back of legs.

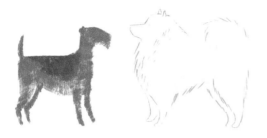
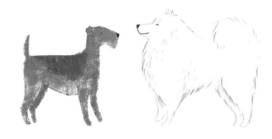

03

Create a warm dark gray mixture using Lamp
Black, Permanent White, and Burnt Umber. Paint
a dark patch on the Welsh terrier's back with
your medium angled brush. Add a tiny bit more
white and paint his neck and tail using the small
round brush. Add a bit of the dark gray mixture
to the pale gray that you mixed for the Samoyed.
Using your small brush, add to the Samoyed's fur
around its neck, chest, tail, and back of legs. Once
that's dry, you can erase any excess pencil lines
around the dogs.

04

Add a bit of the dark gray mixture to the light
brown that you used to paint the Welsh terrier to
create a slightly darker brown. Use that with your
small brush to outline the Welsh terrier. Create
light, broken brushstrokes to give the impression
of curly fur, rather than a solid outline.

Mix Lamp Black with a bit of water and use your
small brush to paint the Welsh terrier's nose and
eye. Use the same black mixture to paint the
nose, eye, and mouth on the Samoyed.

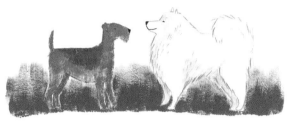

05

Mix a muted green color with Primary Yellow and a little bit of Lamp Black and Permanent White. Use your medium angled brush to paint grass in the background around the dogs. To create the impression of tall grass, start each brushstroke at the bottom of the picture and pull the brush up the page. Do this very carefully around the dogs' legs; you may need to vary the angle of the brush or use your small brush for some areas.

06

Add more Lamp Black and some water to the green mixture and paint individual blades of grass over the first layer of grass using your small round brush. Try to keep these lines as thin as possible. Watering down the green paint will help you do this. Create a peach color with a mixture of Flame Red and Permanent White and use your small brush to paint flowers. Mix a little Burnt Umber and Lamp Black and use the small brush to paint centers in the flowers. Having some of the blades of grass and flowers overlapping the dogs helps ground them in their environment and makes the piece feel more three-dimensional.

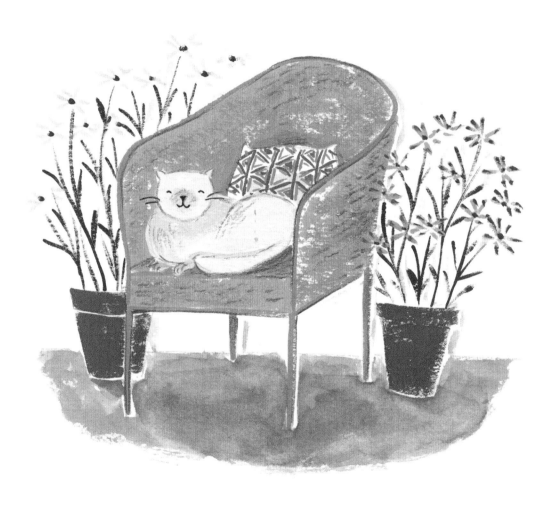

GET STARTED WITH GOUACHE

Cat on a Chair

While on holiday in Mallorca, I spotted a cat sleeping in the sunshine on a wicker chair as I was wandering around a picturesque little village. I made a quick pencil sketch and took a photo so I could finish the painting later. It's always a good idea to keep an eye out for inspiration when you're traveling, which you can record in your sketchbook or by taking a photo. This project allows you to practice composing a scene and also creating an atmosphere within a painting.

TOOLS & MATERIALS

Graphite pencil

Medium round brush

Small round brush

Medium square brush

Eraser

Dark brown pencil

COLORS

Permanent White

Yellow Ochre

Burnt Umber

Lamp Black

Primary Yellow

Flame Red

Permanent Yellow Deep

Burnt Sienna

Permanent Green Middle

01

With a graphite pencil, lightly sketch a cat sleeping on a wicker chair surrounded by plant pots, using my drawing as a reference. Pay attention to the angle of the chair and make sure it doesn't appear lopsided. Keeping the lines of the chair parallel helps the chair feel proportionate.

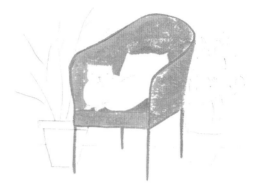

02

Create a mixture of Permanent White, Yellow Ochre, and bit of water. Paint the chair using a medium round brush; allow some of the brush-strokes to be light and textured.

03

Once the picture is dry, add a tiny bit more Yellow Ochre and a little bit of Burnt Umber to the mixture. Pick up the darker paint mixture with a dry medium round brush and lightly brush over the areas you've already painted to create texture. You can test this dry brush technique on a piece of paper first to get the pressure and consistency right. Add a tiny bit more Burnt Umber and Lamp Black to the mixture. With a small round brush, paint the edges and legs of the chair and add shadow to its right-hand side, inside of the chair next to the cushion and under the cat.

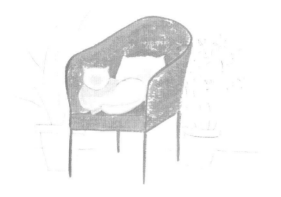 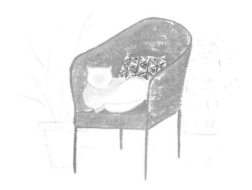

04

Mix up a very pale, warm gray color with Permanent White, Lamp Black, and Burnt Umber. Remember that light colors always dry darker, so use the Lamp Black and Burnt Umber very sparingly. Try the color on some test paper before using it. Paint the cat using your small brush. Add a tiny bit of water to the mixture and paint a shadow on the cushion behind the cat. Add a tiny bit more black to the mixture and add shadow around the cat's tail, under its chin, across its chest, on its front feet, and across its nose.

05

Next mix a muted green color using Primary Yellow with a little bit of Lamp Black and Burnt Umber. Use your small brush to paint a pattern of triangles on the cushion.

Create a pink mixture using Flame Red and Permanent White and add details to the pattern. Mix together Permanent Yellow Deep and Permanent White. Using a small brush, fill in the centers of alternating triangles.

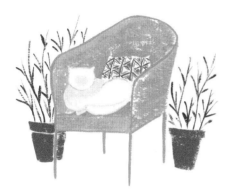

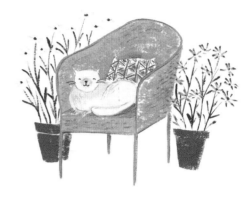

06

Mix Burnt Sienna with Permanent White to create a terra-cotta color. Paint the plant pots using a medium square brush, allowing texture to show.

Mix a dark, muted green color using Primary Yellow, Lamp Black, and a little bit of Burnt Umber and then paint stems on the plant in the pot on the right. Make a dark green mixture using Permanent Green Middle with a little bit of Lamp Black and paint the stems coming out of the plant pot on the left. Once those are dry, erase any excess pencil marks.

07

Create a pale pink mixture using Flame Red and Permanent White. With your small round brush, paint flowers on the plant on the right. To create the daisies on the left-hand side, mix a very pale gray color with Permanent White and Lamp Black and paint the petals. Mix Permanent Yellow Deep with a tiny bit of Lamp Black and paint centers in the gray flowers. Add a tiny bit more Lamp Black to the yellow mixture and paint centers in the pink flowers. Using Flame Red and your small brush, paint the tips of the petals of the pink flowers red. Using a dark brown pencil, add dashes to the wicker chair to indicate a woven texture and to outline the frame of the chair, the plant pots, and the cat. Using Lamp Black and a small brush, paint the cat's features.

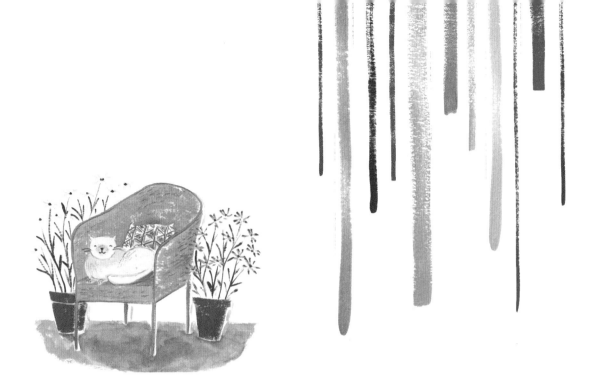

08

Mix Burnt Umber with a little Lamp Black and plenty of water to create a watery mixture. Use your medium round brush to paint the ground under the chair with this mixture. When it's completely dry, add another layer of this mixture directly under the chair to create a shadow; because the watery paint mixture is translucent you can build up depth with layers of paint.

TOP TIP

Because your paint will have covered up the original sketch, redraw the cat's features in pencil again to make sure they are in the correct places before painting them.

PEOPLE

Everyone wants to learn how to draw people, but people are probably the most difficult subjects to paint and draw. Our brains are hardwired to recognize human faces, which means we are irresistibly drawn to them in paintings, but it also means we immediately notice when something is a bit off. When painting objects such as plants, flowers, fruit, and vegetables you have a certain amount of artistic license—if things are a little bit wobbly it doesn't matter. If you paint someone's face a bit wonky, it is immediately noticeable. Unfortunately, there is no quick route to becoming proficient at sketching and painting people. There are some books that explain human anatomy in detail and how to capture it, which can definitely speed up the process, though it will still take hours and hours of practice. The human form is so familiar that often we forget that we need to look at what's actually there before we start drawing.

The very best way to learn how to draw people is to take a life drawing class. Nothing can beat drawing from life, and a good instructor will help you to see what's really there, and not just to draw what you think you know. Don't get too hung up on trying to create a perfect likeness or a photorealistic portrait; focus on capturing the person's personality or body language. Having said that, I definitely don't want to put you off drawing and painting people, it's just good to know that it takes a bit of practice, and you shouldn't be disheartened if things don't turn out quite the way you want them to on your first try.

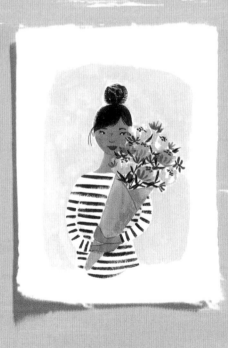

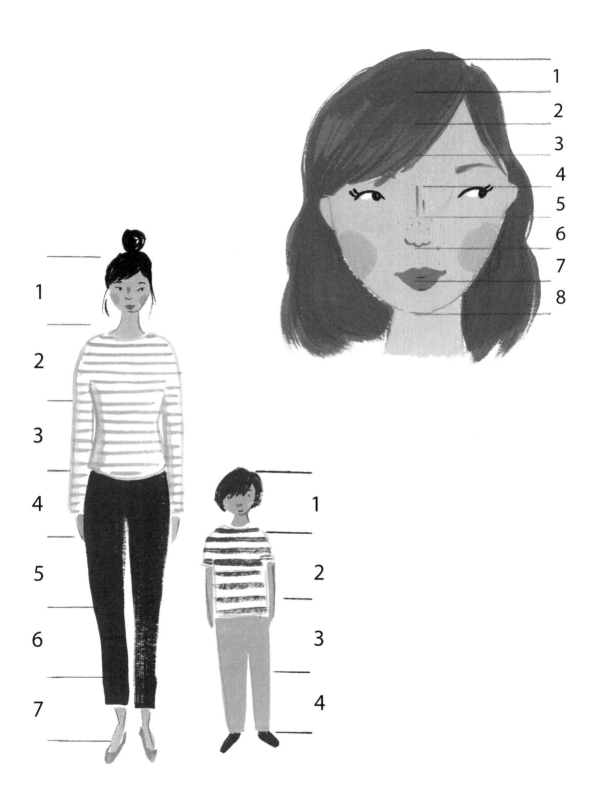

GET STARTED WITH GOUACHE

PROPORTIONS

The drawings on the facing page provide a rough guideline to the proportions of adults and children, although this will obviously vary from person to person. Even if you're working in a highly stylized way, which I do, it's still a good idea to have a basic understanding of human anatomy. Generally the proportions of an adult work out that the height is equal to seven heads. A young child has a much larger head in proportion to their body. The child I've shown here is four heads tall, but this will vary depending on the child's age. The rule of thumb is the younger the child, the bigger the head should be proportionally to their body, and their eyes should be large proportionally to the head. Of course, not everyone sticks rigidly to these rules. In fashion illustration, people are often rendered much taller and thinner, eight or nine heads tall. In children's illustration, artists often take liberties with proportions, rendering people short and round or tall and bendy to give them character.

The drawing on the right indicates the general proportions of the face. The eyes are roughly on the midline of the head and should be level, and the nose is halfway between the eyes and the chin. The lips are halfway between the nose and the chin, and the eyebrows are a quarter of the way up from the eyes to the top of the head. The tops of the ears should be level with the eyes. Again, these are just guidelines to help you get the proportions of the face correct; once you start to get a feel for painting faces, you won't need to refer to these guidelines, it's something that will come naturally.

SKIN TONES

As an illustrator, I paint in a simplified manner, not intended to be realistic. This means I also have a simplified method for painting skin tones. This method will help you paint a whole range of skin tones. Skin tones should always be mixed from scratch; never use tubes of paint labeled as "flesh tint" or "nude." In this lesson we'll be focusing on color mixing and will just be exploring skin tones by creating paint swatches. Using this method, you can adjust the colors you're mixing by adding more Burnt Umber to create a darker skin tone, more Yellow Ochre to create a more golden tone, more Burnt Sienna for a pink tone, and more Permanent White for a paler skin tone.

TOOLS & MATERIALS
Medium round/square brush

COLORS
⬛ Burnt Sienna
⬜ Permanent White
⬛ Yellow Ochre
⬛ Burnt Umber

01

Always start by mixing a small amount of Burnt Sienna into Permanent White. Burnt Sienna is the warmest brown in our set, and most people have warm skin tones. Using a medium brush, paint a small swatch of this color and you should get a pale, pinky skin tone. Add a small amount of Yellow Ochre to the mix and paint another swatch.

TOP TIP

When mixing skins tones, I always start with the lightest color (Permanent White) and then gradually add the darker colors (Burnt Sienna, Yellow Ochre, Burnt Umber) until I get the correct color. It's easy to make a color darker with a little bit more paint, but if you need to lighten a color you will need to add a lot of white.

02

Add more Yellow Ochre and more Burnt Sienna and paint another swatch. Keep adding more Burnt Sienna and more Yellow Ochre and painting swatches, creating progressively deeper and darker skin tones.

03

Add a tiny bit of Burnt Umber to the mixture and paint another swatch. Keep adding more Burnt Umber and Burnt Sienna to the mixture and painting swatches to create more progressively deeper skin tones. At the end you should have a whole range of skin tones.

Simple Faces

This project will help you practice mixing a range of skin tones and capture personality with these simple portraits. Once you've practiced these, you might want to have a go at painting your friends or family. Think about what distinctive characteristics would make them immediately recognizable. Use a variety of brushstrokes to capture different textures of hair. Painting the delicate facial features will also help you improve control of the brush.

TOOLS & MATERIALS

Medium round brush
Small round brush

COLORS

◻ Permanent White
◼ Burnt Sienna
◼ Burnt Umber
◼ Yellow Ochre

◼ Lamp Black
◼ Spectrum Red
◼ Flame Red

01

Working from left to right, top to bottom, use a medium round brush to paint simple oval-shaped faces and necks. For the first face, use a mixture of Permanent White and Burnt Sienna. For the second face, use a mixture of Permanent White, a little bit of Burnt Sienna, and Burnt Umber. For the third face, use a dark mixture of Permanent White and slightly more Burnt Sienna and Burnt Umber than the previous mix.

02

For the fourth face, use a very light mixture of Permanent White and Burnt Sienna. For the fifth face, use a mixture of Permanent White, Burnt Sienna, and Yellow Ochre. For the sixth face, use a mixture of Permanent White and a little bit of Yellow Ochre.

03

Add hair to the faces using a small round brush. Add short hair to the first face using Burnt Umber. To create the look of wavy hair, use short curved brushstrokes. For straight hair, use short straight brushstrokes and for curly hair use small spirals. Add long black hair to the second face using Lamp Black. Start the brushstrokes at the scalp and pull the brush down, finishing with dry feathery brushstokes that look like hair. Use a dry mixture of Lamp Black to add hair to the third face; you want the black mixture as dry as possible to give it texture. Use light dabbing brushstrokes to build up volume and texture. Create a mixture of Permanent White, Yellow Ochre, and a little bit of Burnt Umber and paint medium-long hair on the fourth face, starting at the roots and finishing at the tips. Paint short hair on the fifth face using Lamp Black and short brushstrokes. The angle of the hair will define the angle of the face. Using downward brushstrokes, paint straight black hair on the sixth face using Lamp Black.

04

Use your small brush and Burnt Umber with a little bit of water to add noses to the faces with darker skin tones. Use a mixture of Permanent White, Burnt Sienna, and Burnt Umber to make light brown and paint noses on the paler skin tones. Using this color, paint freckles on the fourth face. Use this same brown and your small brush to paint lips on the first and fifth faces. Create a mix of Spectrum Red with Permanent White and a little bit of water. With your small round brush, add lips to the second face. Paint the line of the top lip first, then the bottom lip, then fill in the middle. Use Spectrum Red to add lips to the third face. Create a pink mixture of Flame Red and Permanent White and use it with your small brush to paint lips on the fourth and sixth faces. Add more Permanent White to the pink mixture and add cheeks to the fourth face.

05

Using your small brush and Lamp Black, paint eyes on all of the faces. With Permanent White and your small brush add white to the eyes on the faces with darker skin tones. Using your small brush and Burnt Sienna paint glasses on the fourth face. Add eyebrows to each person using your small brush and the color that matches their hair. Use the light brown you mixed earlier to carefully paint a line with your small brush to indicate the chin on the women. Use the light brown and your small brush to add lines to the fourth face.

06

With your medium brush and Lamp Black, paint a simple T-shirt on the first person. Mix Permanent White and Lamp Black to make light gray. Use your small brush to outline a simple T-shirt on the second person. Mix Flame Red and Permanent White to make peach and then paint stripes on the T-shirt using your small brush. Using your small brush and Lamp Black paint a turtleneck top on the third person. Using the light gray you already mixed and your small brush, outline a collared shirt for the fourth and fifth persons. Use the light gray to outline a simple T-shirt on the sixth person and add peach polka dots using your small brush.

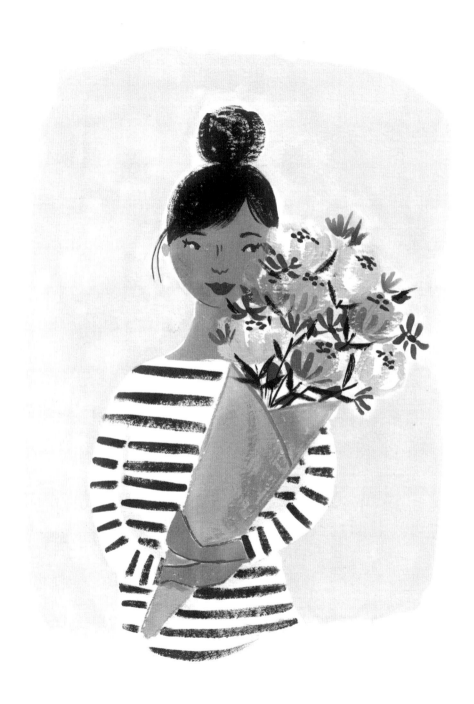

GET STARTED WITH GOUACHE

Girl with Flowers

This simple composition brings together a few of my favorite things—stripes, flowers, and the color pink. Building on the skills you've already learned for mixing skin tones and painting faces (see pages 118 and 121), you can now paint someone from the waist up. You can adapt this piece in many ways: try different color palettes, skin tones, and hairstyles.

TOOLS & MATERIALS

Pencil

Small round brush

Medium round brush

Eraser

Medium angled brush

COLORS

Permanent White

Yellow Ochre

Burnt Sienna

Burnt Umber

Lamp Black

Flame Red

Permanent Yellow Deep

Primary Yellow

Permanent Green Middle

01

With a pencil, sketch a girl holding a bunch of flowers, using my drawing as a reference. First, lightly sketch an oval for her face. Next, roughly sketch her neck and body and then the flowers. Once you have a rough outline of the girl sketched, you can fill in more details, like her face and hair.

02

Mix up a skin color using Permanent White with
Yellow Ochre and Burnt Sienna. Paint the girl's
face, neck, and hands using a small round brush.

03

Mix up a light brown color for the paper wrapped
around the flowers using Permanent White,
Yellow Ochre, Burnt Umber, and a little bit of
Lamp Black. Use a medium round brush to paint
the paper. Add a tiny bit more Lamp Black to the
mixture and paint a thin line using your small
brush to show where the paper overlaps. Roughly
add a shadow to the right side of the paper using
this darker mixture and your small brush.

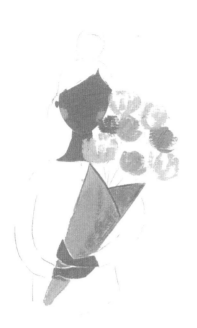

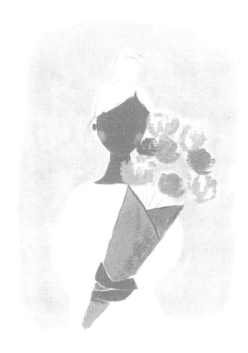

04

Create a light pink mixture with Flame Red and Permanent White and roughly paint peonies with your small round brush, using dry brushstrokes. Add more white to the mixture to paint lighter peonies, leaving areas of white showing through. Rub out pencil marks around the flowers with an eraser.

05

Mix up a very light pink color with Permanent White, lots of water, and a tiny bit of Flame Red. Using a medium angled brush, paint in the background. Carefully paint around the flowers using your small round brush. Use the eraser to rub out the arm pencil lines so you can still see a faint impression of the lines but most of the graphite is gone. Use the very light pink to paint the shadows around the girl's arms.

06

Using Lamp Black and the small round brush, paint stripes on the girl's T-shirt. Don't add any water to the Lamp Black so the stripes are dry and textured. Use the same black to paint the girl's hair. The girl's topknot should have a soft texture similar to the peonies. For her bangs, pull the brush down from the top of the head, finishing with feathery brushstrokes.

07

Mix a deep pink color with Flame Red and Permanent White and add detail to the bottom of the pink peonies. Add more Flame Red to the mixture and paint pink flowers using your small round brush. Add Permanent Yellow Deep to the center of the flowers. Create a light green mixture using Primary Yellow, Permanent White, and Lamp Black. Paint small leaves dotted around the flowers, using your small round brush. Mix up a dark green color using Permanent Green Middle and Flame Red. Use the dark green mixture to paint stems and leaves with your small brush, painting over the lighter leaves in places.

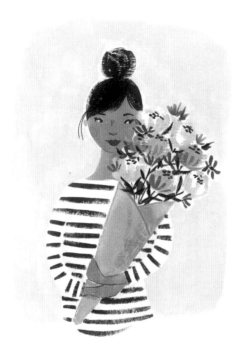

08

Add a tiny bit more Burnt Sienna and Burnt
Umber to the skin color you mixed at the
beginning. Using your small brush, outline the
girl's hands and under her chin, and paint her
nose. Using Lamp Black and your small brush,
paint the girl's eyebrows and eyes. Using Flame
Red and your small brush, paint the girl's lips.
Add white to the Flame Red and paint the girl's
cheeks using your small brush. Add a dab of
Permanent White to show the whites of her eyes
using your small brush.

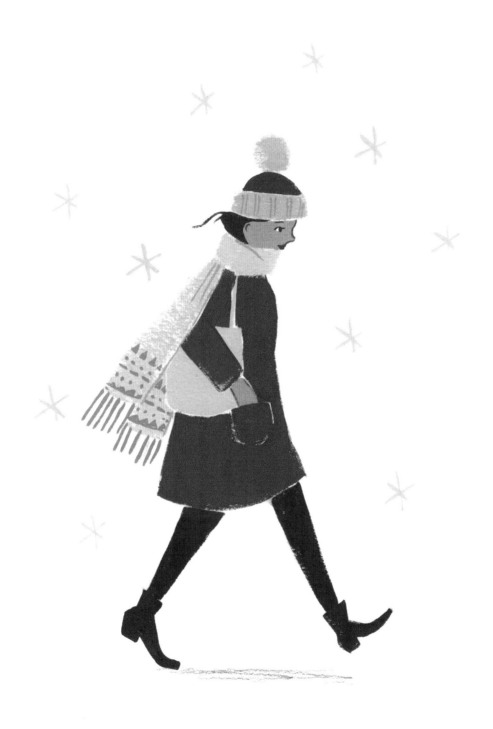

GET STARTED WITH GOUACHE

Walking in the Snow

This piece builds on the skills you've already developed in drawing people, but it is slightly more tricky because movement is added. The girl is wearing a warm winter outfit, which means lots of lovely colors and textures to paint. You can customize this piece using your own color palette.

TOOLS & MATERIALS

Graphite pencil

Small round brush

Medium round brush

Medium angled brush

Dark brown pencil

COLORS

☐ Permanent White

⬤ Burnt Sienna

⬤ Yellow Ochre

⬤ Lamp Black

⬤ Permanent Yellow Deep

⬤ Flame Red

⬤ Primary Blue

⬤ Permanent Green Middle

01

With a graphite pencil, start by sketching a girl wearing a hat, coat, tote bag, and scarf, using my sketch as reference. Pay attention to the angle of her feet: the toes of her front foot should be pointing up and the toes of her back foot should be pointing down.

02

Mix up a skin color using Permanent White, Burnt Sienna, Yellow Ochre, and little bit of water. Using a small round brush, paint the girl's face and hand. Using Lamp Black and your small brush, paint the girl's legs, boots, and hair.

03

Make a deep orange mixture using Permanent Yellow Deep, Burnt Sienna, and some water. Paint the girl's coat using a medium round brush.

04

Create a pale pink mixture using Permanent White and Flame Red with no water. Paint the scarf using a medium angled brush. Applying a dry mixture of paint with an angled brush should result in a fluffy texture. Add a tiny bit more Flame Red to the mixture and paint the pompom and band of the girl's hat using your small round brush. Try to keep the texture as dry and fluffy as possible.

Paint the girl's tote bag using a mixture of Permanent White, Primary Blue, Permanent Yellow Deep, and some water with your small round brush. Paint the middle section of the girl's hat using Permanent Green Middle and your small round brush.

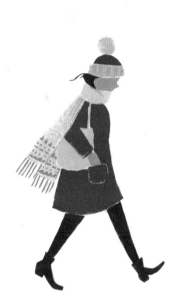

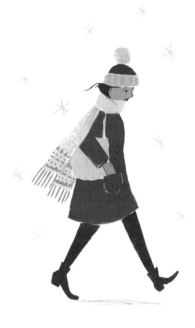

05

Add a tiny bit more Flame Red to the pink mixture and a little bit of water. Using your small round brush, paint tassels and a pattern on the girl's scarf. Add details to the band of her hat. Use the same pink paint and your small round brush to paint a round rosy cheek.

06

Use Burnt Sienna and your small brush to outline the girl's arm, hand, pocket, ear, and profile. Create a mixture of Burnt Sienna and Flame Red to paint the girl's lips. Use Lamp Black to paint the girl's eyebrow and eye. Add a dot of Permanent White to her eye. Use the pale blue mixture from the tote bag to paint snowflakes around the girl using your small round brush. Use a dark brown pencil to add a shadow beneath the girl.

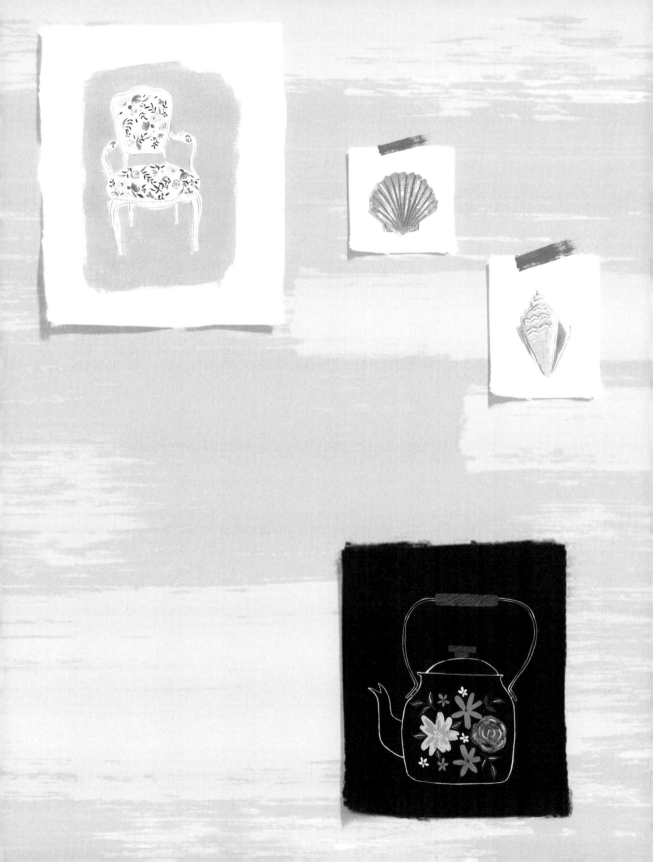

OBJECTS

The following projects illustrate how simple things found around the house can provide rich inspiration for your paintings. Colorful or decorative furniture and objects are a great starting point for painting because they test your color mixing skills and challenge you to find the right technique to paint your subject. Part of developing your skills as an artist is deciding what techniques to use for each painting. In some instances, diluted layers of gouache work well; for others, dry-textured paint or negative space is the way to go. By using objects around the house, you learn to find artistic inspiration in your everyday life.

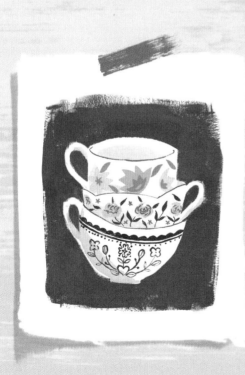

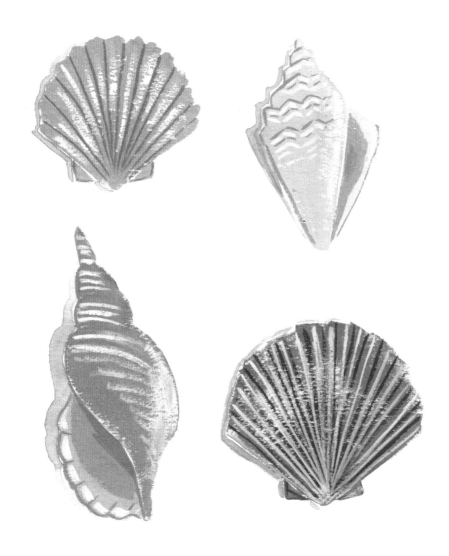

Shells

This collection of shells is painted using a muted and limited color palette. By using just the three primary colors and white, you can create every color you need to paint this simple still life, which will really help develop your color mixing skills.

TOOLS & MATERIALS

Pencil

Medium round brush

Medium angled brush

Small round brush

Eraser

COLORS

☐ Permanent White

◼ Flame Red

◼ Permanent Yellow Deep

◼ Ultramarine

01

With a pencil, start by lightly sketching the shells, using my drawing as a reference. If you have seashells at home you can use those as well.

02

Make a pale peach color with Permanent White, Flame Red, and a tiny bit of Permanent Yellow Deep. Paint the scallop shell on the top left with a medium round brush, pulling each brushstroke from the outside edge of the shell into the bottom point.

Mix a pale purple-gray color using a mixture of Flame Red, Ultramarine, a little bit of Permanent Yellow Deep, lots of Permanent White, and some water. You will need to carefully balance the three primary colors to achieve this muted color. Using your medium round brush, paint the shell on the top right. Add more white to the mixture and paint the edge of the shell on the right side. Make a darker mixture of the same color and paint the inside of the shell.

03

Mix up a muted pink color with Flame Red, Permanent White, and a tiny bit of Ultramarine. With a medium angled brush, paint the large scallop shell on the bottom right using the same technique as the top scallop shell, pulling the brush from the outside in toward the bottom point of the shell. Use a small round brush to paint the flat-sided hinge on both sides of the point.

Mix up a muted cream color using Permanent Yellow Deep, Permanent White, a little bit of Flame Red, and a little bit of Ultramarine. Paint the pointed shell on the bottom left. Add more white to the mixture and paint the outside edge on the left side. Add a tiny bit more Ultramarine to the mixture and paint the inside of the shell. When they are all dry, rub out any remaining pencil marks with an eraser.

04

Add a tiny bit more Flame Red to the peach color mixed at the beginning. Use your small brush to carefully paint lines on the scallop shell on the top left. For the shell on the top right, use the darker shadow color you already mixed to outline the left-hand side and paint grooves on the outside of the shell using your small brush.

05

For the shell on the bottom left, use the darker shadow color you mixed to outline the left-hand side and paint grooves on the outside of the shell using your small brush. Mix a slightly darker color by adding a tiny bit of Ultramarine to the mix and paint a shadow on the inside of the shell using your small brush. For the shell on the bottom right, add more Flame Red and some water to the muted pink you created and carefully paint thin lines using your small brush. The paint mixture needs a little bit of extra water to help it flow smoothly over the rough texture of the first layer of paint.

06

Use Permanent White and your small brush to paint white lines in between the darker lines on the shell on the top left. Use your small brush and Permanent White to paint grooves on the outside of the shell on the top right, and to add a highlight to the right side. Again, use white and your small brush to add grooves to the bottom-left shell and a highlight on the left side. Mix a bit of water with Permanent White and carefully paint white lines in between the darker lines on the shell on the bottom-right side.

07

Carefully mix up a pale, warm gray color using Permanent White with a little bit of Flame Red, Permanent Yellow Deep, Ultramarine, and lots of water. Using your small brush, carefully paint a shadow around the left side of each shell.

This project is all about clever color mixing. When mixing a chromatic gray—a gray made out of all three primary colors rather than black—subtlety is the key. Add small amounts of each color gradually until you achieve the desired result.

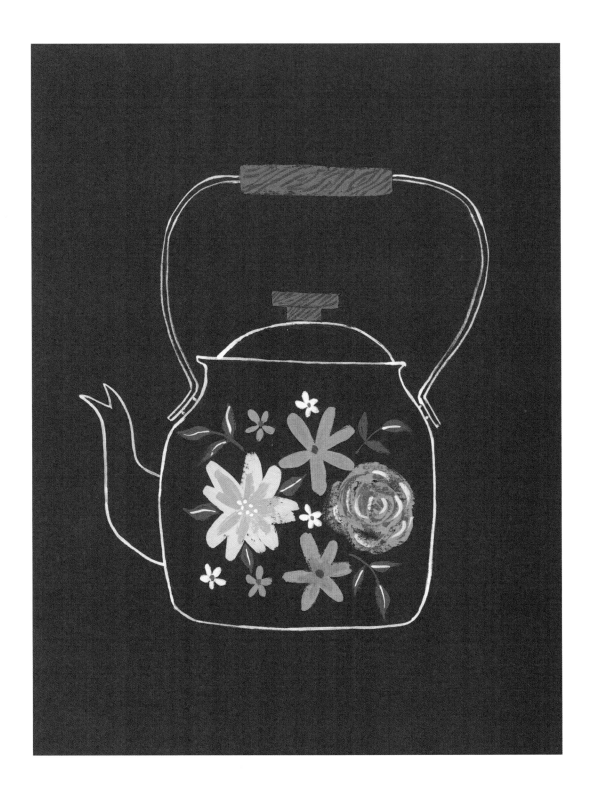

Enamel Teakettle

This piece was inspired by an old-fashioned painted enamel teakettle. I love taking inspiration from vintage and antique shops. Using black paper and rich, opaque gouache is the perfect way to capture this brightly patterned teapot. This design is bold and simple and can easily be adapted using other flowers or color schemes.

TOOLS & MATERIALS

Pencil

Black paper

Small round brush

Medium round brush

COLORS

Permanent White

Primary Blue

Permanent Yellow Deep

Flame Red

Permanent Green Middle

Burnt Umber

Yellow Ochre

01

Using a pencil, lightly sketch the outline of a vintage teakettle on a piece of black paper. (A regular graphite pencil should show up on the black paper as the gray color of the graphite is slightly light reflective.) Mix a tiny bit of water with Permanent White. You want the paint mixture thick enough that it is opaque but thin enough that you can achieve thin lines. Use a small round brush to outline the teapot and lid.

02

Mix up a light blue color using Permanent White and Primary Blue. Use a medium round brush to paint a flower. Start each brushstroke at the tip of the petal and then pull inward toward the center. Rotate the paper after each petal. Add a tiny bit more Primary Blue to the mixture and paint a smaller flower in the center of the first using the same process.

Mix up a pale yellow color using Permanent White and Permanent Yellow Deep and paint flowers with six petals using your medium round brush. For each brushstroke, start at the tip of the petal and pull in toward the center of the flower, turning the paper with each petal. Use your small round brush with Permanent Yellow Deep straight from the tube to paint a center in each flower.

03

Create a pale pink mixture using Flame Red and Permanent White. Using your medium round brush, paint a rose with loose, curved brush-strokes. Using the same pink mixture and your small brush, paint two smaller flowers. Add more Flame Red to the mixture and use your small brush to paint petals on the rose and add a center to the small flowers.

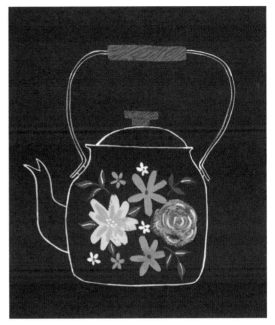

04

Combine Permanent Green Middle with a bit of
Flame Red and Permanent White and use your
small round brush to paint leaves around the
flowers. Using Permanent White with a little
bit of water and your small round brush, paint
small white flowers. Continue to add more detail
to the pink rose by painting thin curved lines to
create the effect of highlights on the rose petals.
Paint dots in the center of the blue flower, and
paint center lines in the leaves. Add a small
dot of Permanent Yellow Deep to each of the
white flowers.

05

Make a pale brown mixture of Burnt Umber,
Yellow Ochre, Permanent White, and a small
amount of water. Using your medium round
brush, paint the handle of the teakettle and
the knob on the lid. Add a tiny bit more Burnt
Umber to the mixture and, with the small round
brush, paint wood grain on the handle and knob.

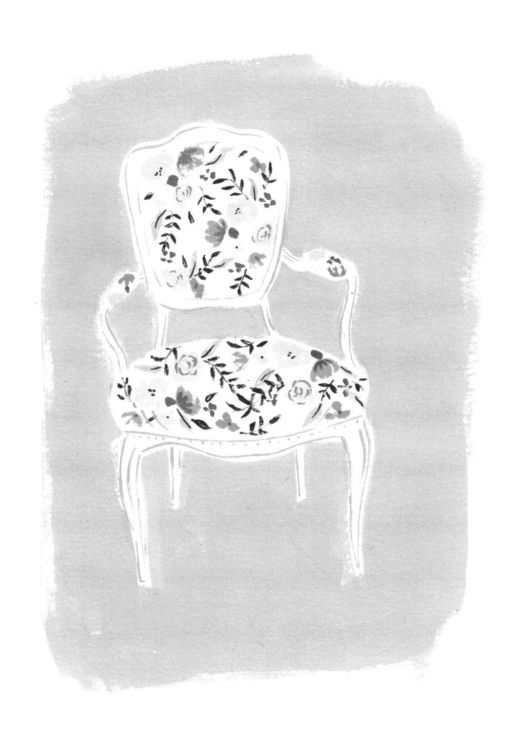

Armchair

I love getting ideas from trips to historic homes and antique shops. This piece, inspired by a beautifully upholstered rococo-style chair, combines delicate areas of pattern with big, bold blocks of color and makes use of negative space.

TOOLS & MATERIALS

Pencil

Medium angled brush

Small round brush

Eraser

COLORS

Permanent White

Primary Blue

Permanent Yellow Deep

Lamp Black

Flame Red

Permanent Green Middle

01

Start by sketching the chair in pencil, using my drawing as a reference. Pay attention to the length and angle of the legs. The legs at the back appear shorter, which gives a sense of depth.

02

Mix up a muted blue-green color using Permanent White, Primary Blue, a little bit of Permanent Yellow Deep, and some water. You will need lots of this paint mixture as you are using it for the background. Paint the background around the chair using a medium angled brush, leaving the edges rough. Use a small round brush to fill in the background behind the arms of the chair.

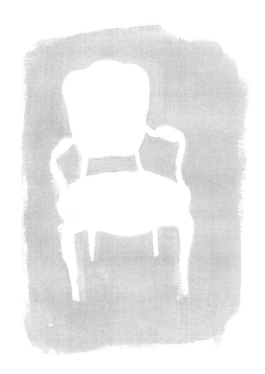

03

Mix up a pale gray color using Permanent White, a little bit of the blue-green background mixture, a little bit of Lamp Black, and lots of water. Paint shadows on the soft upholstered areas of the chair. Rub out the pencil marks using an eraser.

04

Mix up a muted duck-egg blue color using Permanent White, Primary Blue, and a little bit of Permanent Yellow Deep. Paint rough flowers on the chair using your small round brush. I like to paint flowers using a dry mixture of paint and loose brushstrokes. I find the raw edges make them look fresh and stop them from being overworked. Mix a pale pink color using Flame Red and Permanent White. Using your small brush, add more flowers to the pattern. Add more Permanent White to the pink mixture and add some large flowers. Use a mixture of Permanent Yellow Deep and Permanent White and paint small flowers.

05

Use the original blue-green mixture that you created for the background to paint some large leaves around the flowers with your small round brush. Mix up a dark green color using Permanent Green Middle with a little bit of Flame Red and paint vines and small leaves around the flowers.

06

Use the dark green color to add a line down the middle of the large leaves and to add dots to the center of the blue flowers. Add a bit of Flame Red to the pale pink mixture and paint petals on the large flowers. Add a bit more Flame Red and paint details on the larger flowers.

Mix up some gray using Permanent White, Lamp Black, and some water. Using your small brush, add outlines to the wood.

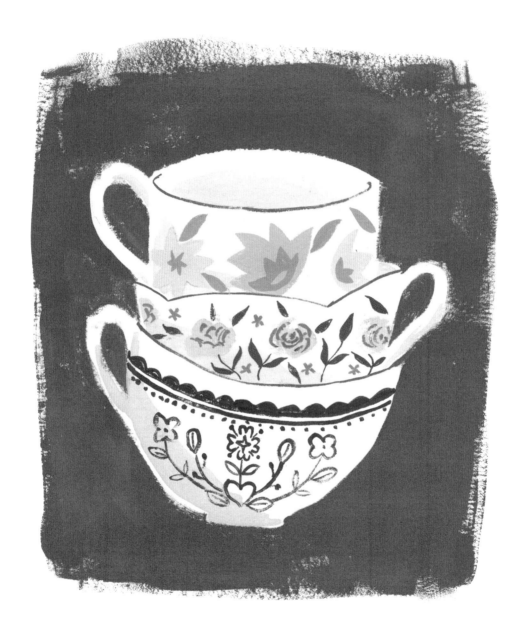

Stacked Teacups

This piece utilizes negative space. Painting the area around the white teacups makes them really stand out. You can adapt this piece using different color palettes and different patterns on the cups. Try stacking some of your own teacups or mugs and sketching them.

TOOLS & MATERIALS

Pencil

Medium angled brush

Small round brush

Eraser

COLORS

 Permanent Yellow Deep

Yellow Ochre

Permanent White

Lamp Black

Ultramarine

Flame Red

Permanent Green Middle

Spectrum Red

01

With a pencil, sketch three stacked teacups, using my sketch as reference. If you have similar teacups at home, you can have a go at stacking those and sketching from life.

02

Start by mixing a rich mustard yellow color using Permanent Yellow Deep, Yellow Ochre, and Permanent White with a tiny bit of water. Use a medium angled brush to paint the area around the teacups, creating a rough rectangle. Paint the areas closest to the cups more carefully and leave the edges of the rectangle rough and textured. You may need a small round brush to paint around the handles of the teacups.

Carefully rub out the pencil lines closest to the painted edges with an eraser, but leave the patterns in the center of the mugs.

Mix up a very pale yellow-gray using Permanent White, Yellow Ochre, Lamp Black, and lots of water. Paint shadows on the teacups using your small brush.

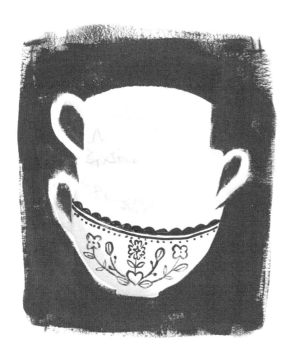

03

Once the background is completed and dry, use Ultramarine and your small brush to paint the pattern on the bottom teacup, using my artwork as reference. Don't rush this part; take it slowly and paint the details as delicately as possible. You can mix some water with the Ultramarine to make it thinner and easier to control.

04

Mix up a pale pink color using Permanent White and Flame Red. With the small round brush, paint the roses on the second cup. When that is dry, make a dark pink mixture with Flame Red and Permanent White and add details to the roses, using your small brush. Paint small flowers with the same mix. Mix Permanent Green Middle with a little bit of Flame Red and a little bit of water to create a dark, muted green. Use your small brush to paint leaves and stems.

05

Create a muted pale purple mixture with Permanent White, Ultramarine, and a little bit of Spectrum Red. Paint the largest flower on the top cup with your small brush. Add a tiny bit more white and paint the two small flowers on either side. Add a bit more Ultramarine and some Lamp Black to the mixture and paint the leaves and add details to the flowers.

06

When the paint is completely dry, erase any remaining pencil marks. Using the original yellow color you mixed for the background, carefully draw a line between each cup.

PLACES

Painting on location is a really fun way to develop your work and find new inspiration. Travel has had a huge influence on my work—I'm so captivated by landscape, architecture, folk art, and traditional crafts.

An easy way of painting with gouache when you're traveling is to take a small set of watercolors and one tube of white gouache. You can mix the pigment from the watercolors on the palette with some white gouache to create a whole range of colors. This means you don't need to bring lots of tubes and a separate palette with you, and it gives you the versatility of painting with watercolors as well. I also recommend taking a small sketchbook with nice thick paper and a couple of pencils with you. If you don't feel confident painting outdoors, take photos of things that catch your eye, then paint them when you get home while they are still fresh in your mind.

Window with Laundry

This piece is inspired by the colorful shuttered houses found in Venice, Italy. It relies heavily on using square and angled brushes to create texture, flat areas of color, and straight lines. The painting contrasts warm and cool colors. Pale purple, deep green, and gray are all cool, while the warm plant pots and laundry add contrast and draw your eye around the painting.

TOOLS & MATERIALS

Graphite pencil

Ruler (optional)

Medium square brush

Small round brush

Eraser

Medium angled brush

Dark brown pencil

Warm brown pencil

Red pencil

COLORS

Permanent White

Ultramarine

Spectrum Red

Permanent Green Middle

Flame Red

Lamp Black

Burnt Sienna

01

With a graphite pencil, lightly sketch a window with shutters, two flowerpots, and three pillow-cases hanging underneath, using my sketch as a reference. I prefer the softer look of a freehand sketch, but you can use a ruler for the straight lines, if you prefer.

02

Create a very pale purple mixture by combining Permanent White, Ultramarine, a tiny bit of Spectrum Red, and some water. You will use this color for the background, so make sure you mix up plenty. Use a medium square brush to paint around the window and laundry with broad brushstrokes. The square shape of the brush should make it easy to paint large flat areas quickly. Use a small round brush to fill in any awkward shapes between the laundry and window. When the background is completely dry, erase the pencil lines around the edges.

03

Mix up a deep green color using Permanent Green Middle with a little bit of Flame Red and Permanent White. Using your medium square brush, paint the shutters using broad brushstrokes. The thick mixture of paint and the square brush should create lots of texture around the edges. You may need to paint brushstrokes starting from the top and bottom of the shutters to create an even finish. You can turn the paper around as you do this.

04

Make a dark gray mixture using Permanent White, Lamp Black, Burnt Sienna, and some water. The paint should have a thin, watery consistency. Paint the inside of the windows using your medium square brush.

Mix a warm brown color using Burnt Sienna and Permanent White. Use a medium angled brush to paint the two plant pots and one of the pillowcases on the line.

05

Mix a pale warm gray color using Permanent White, Lamp Black, Burnt Sienna, and water. Using your small round brush, add shadows behind the terra-cotta pots and outline the windowsill. Add more water to the mixture; outline the large pillowcase with your small round brush and add shadows to the center of the pillowcase with broad rounded brushstrokes.

Create a pale pink mixture with Permanent White and Flame Red and use your medium angled brush to paint the remaining pillowcase.

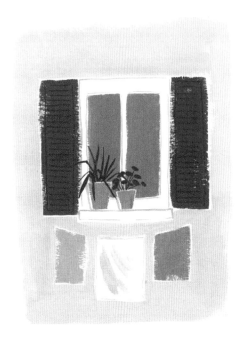

06

Combine Permanent Green Middle and Flame
Red to make a dark green. Using your small
round brush, paint vertical and horizontal lines
on the shutters. With the same color and your
small round brush, paint long thin leaves coming
out of the larger plant pot and circular leaves on
stems coming out of the smaller plant pot.

07

When the leaves are dry, use the pale pink you
mixed earlier and your small brush to paint
geranium flowers on the small plant pot. Use
a dark brown pencil to outline the windowsill
and draw the clothesline. Use a warm brown
pencil to add shadows to the plant pots and
pillowcase on the right. Use a red pencil to add
shadow to the pink pillowcase and add detail
to the pink geranium flowers.

08

Add more Ultramarine and Spectrum Red to the pale purple mixture you made at the beginning. If the pale purple has dried up, add a drop of water to rewet it and mix well. Use this color and your small brush to add shadows to the left side and underneath the shutters and laundry and to paint bricks on the wall. Using your small brush, add flowers to the plant on the left and paint a checked pattern on the white pillowcase.

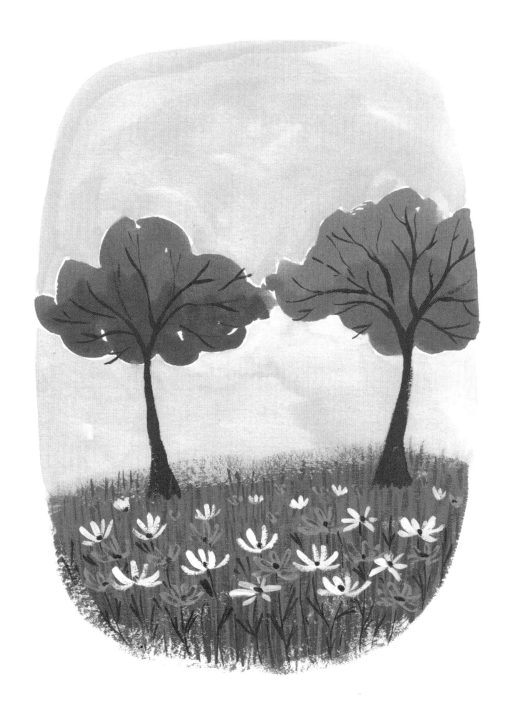

Autumnal Trees

This piece uses diluted gouache to build up depth in the painting and create soft shapes. The most diluted layers of paint recede into the background while the thicker, drier layers of paint stand out in the foreground. The color palette is inspired by warm autumnal colors.

TOOLS & MATERIALS

Large round brush

Medium angled brush

Small round brush

COLORS

Burnt Sienna

Permanent White

Yellow Ochre

Flame Red

Permanent Yellow Deep

Primary Yellow

Lamp Black

Burnt Umber

01

Mix a warm brown color using Burnt Sienna, a tiny bit of Permanent White, and lots of water. Paint a loose cloud-shaped treetop using a large round brush. While the paint is still wet, add more of the Burnt Sienna mixture to the bottom of the shape to add depth and shadow. The darker color should blend in slightly while they are both still wet.

02

Combine Yellow Ochre with a little bit of Permanent White, a tiny bit of Burnt Sienna, and lots of water. Paint another cloudlike shape using your large round brush. Add more watery Yellow Ochre to the bottom of the shape while it is still wet and allow the colors to blend. I've intentionally cut off the edge of the right tree so it looks like it's in a frame.

03

When that layer is completely dry, mix up a very pale peach color using Permanent White with a little bit of Flame Red and Permanent Yellow Deep and lots of water. Paint the background behind the two cloud shapes using your large round brush. It's okay to leave a tiny bit of white paper in between the shapes and the background.

04

Once the background is dry, mix a warm, muted green color using Primary Yellow, a little bit of Permanent Yellow Deep, a little bit of Lamp Black, and lots of Permanent White. Using a medium angled brush, paint the grass using dry textured brushstrokes at the bottom of the painting.

05

Create a dark brown mixture using Burnt Umber, Lamp Black, a little bit of Permanent White, and a little bit of water. Using a small round brush, paint the tree trunks and branches. Make the branches of the trees thinner as you get closer toward the edges.

06

Add more Permanent Yellow Deep and Lamp Black to the green you mixed for the grass to make it darker. Paint blades of grass using your small round brush, making the blades of grass longer at the bottom of the picture and shorter toward the trees. Add more Lamp Black to the green mixture and paint more blades of grass in the same way. To make it look denser, add more blades of grass to the bottom of the picture.

07

Use Permanent White and your small brush to paint daisies in the field, making them larger toward the bottom of the picture and smaller toward the trees to create a sense of perspective. To create each petal, drag the brush from the tip of the petal toward the center. Create a mixture of Flame Red, Permanent Yellow Deep, and Permanent White and paint more daisies using the same technique. Use Permanent Yellow Deep and your small brush to add a center to the larger flowers. Use a mixture of Flame Red and Permanent Yellow Deep and your small brush to add a line of darker color to each of the pink flowers.

08

Mix a dark green color using Primary Yellow and Lamp Black and some water. Paint stems and leaves on the flowers in the foreground.

TOP TIP

You can buy brushes with hollow plastic handles that can be filled with water, which makes them ideal for painting on the go. They are available in different sizes and are a useful addition to your painting kit.

Pink Town House

I took my inspiration for this piece from the pretty rows of pastel-colored houses found in Notting Hill, West London. Layers of paint are used to build up different textures to create a portrait of a house. Once you've mastered this project, have a go at painting a portrait of your own home.

TOOLS & MATERIALS

Graphite pencil

Ruler (optional)

Medium square brush

Small round brush

Eraser

Red pencil

COLORS

☐ Permanent White

◼ Flame Red

◼ Permanent Green Middle

◼ Lamp Black

◼ Yellow Ochre

TOP TIP

Small paintbrushes wear out quickly because they have fewer bristles than larger brushes. When it becomes difficult to get the bristles to make a fine point and stray hairs stick out, a brush needs replacing. If you're struggling to neatly paint the fine lines in a project, it might be time to replace your brush.

01

WIth a graphite pencil, lightly sketch a town house, using my drawing as reference. I prefer to sketch freehand, but you can use a ruler for the straight lines, if you prefer. Start by sketching a tall rectangle to make the outline of the house. Then roughly outline other rectangles for the door and windows. Once you've got the right-size rectangles in the right places, you can add more details to them.

02

Mix a pale pink color using Permanent White, Flame Red, and water. Paint the facade of the house, applying smooth even brushstrokes with a medium square brush.

03

Create a green mixture using Permanent Green Middle, a little bit of Flame Red, and a little bit of Permanent White. Use your medium square brush to paint the front door with broad vertical brushstrokes.

04

Mix up a pale gray color using Permanent White, Lamp Black, and water. Use a small round brush to paint the windowsills, window frames, and steps, and to outline the window panes and add details to the roof. Paint these lines as neatly and delicately as you can. Once the paint is dry, rub out the pencil lines with an eraser.

05

Using Lamp Black and your small round brush, paint the window boxes and the railings. Don't add any water to the black paint to get a slightly dry, textured effect.

Use a mixture of Yellow Ochre and Permanent White and your small brush to paint a letterbox and knocker on the front door.

06

Mix a dark green color using Permanent Green Middle and Flame Red and add details to the front door using your small round brush. Paint long rectangles on the door to show beveled details. Use a mixture of Yellow Ochre, Lamp Black, and water and your small round brush to add details to the letterbox and knocker. Create a very pale, very watery mixture of Lamp Black and Permanent White. With your small round brush, paint shadows on the window panes, behind the railings, around the edges of the window frames, and on the steps.

07

When the shadows are completely dry, mix up some Flame Red and Permanent White with a little bit of water. Use your small round brush to paint tulips in the flower boxes. Use the green color you mixed for the door with a little bit more water and your small round brush to paint the tulip stems and leaves. For the leaves, start the brushstroke at the base of the stem, then pull the brush upward, ending in a point.

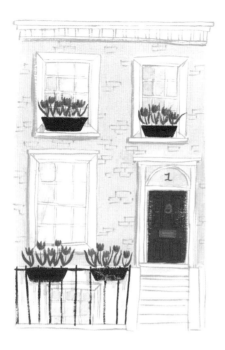

08

Mix up a pink slightly darker than the color of
the house using Permanent White, Flame Red,
a tiny bit of Permanent Green Middle, and some
water. Using the small round brush, add shadow
to the left side and underside of the door and
window sills. Use this paint mixture and your
small round brush to very carefully paint bricks
randomly across the front of the house. With a
red pencil, add shadow to the bottom and left
side of the red tulips. Use Yellow Ochre mixed
with water and your small round brush to paint
a number above the front door.

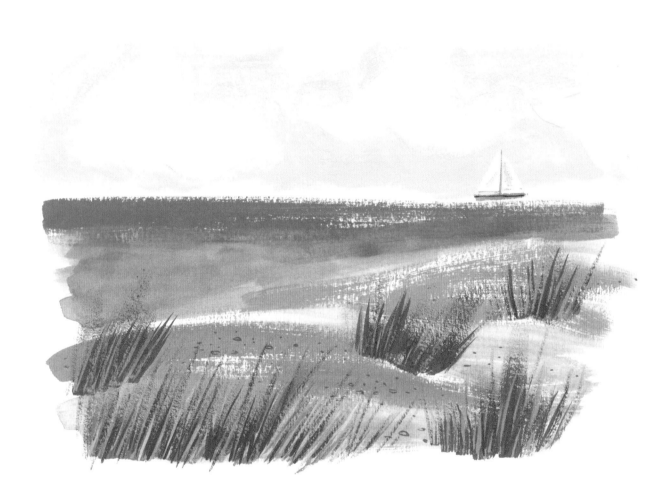

Windswept Beach

To build up a picture of a windswept beach, you will use loose brushstrokes and a variety of textures, both wet washes of paint and dry textured paint. Much of this picture was made using a medium angled brush, demonstrating the versatility of that brush.

TOOLS & MATERIALS
Medium angled brush
Small round brush

COLORS
Permanent White
Yellow Ochre
Burnt Umber
Ultramarine

Primary Yellow
Primary Blue
Lamp Black
Flame Red

01
Mix a sand color using Permanent White, Yellow Ochre, a little bit of Burnt Umber, and some water. Use a medium angled brush to roughly paint curved horizontal stripes across the lower half of the paper. Add more water to your brush and paint some lighter watery areas.

TOP TIP

Practice painting different brushstrokes with your angled brush on a piece of scrap paper first to get confident using it and to explore the range of marks that can be produced by varying the angle of the brush and the pressure.

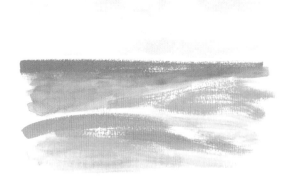

02

Create a muted blue mixture using Ultramarine, a little bit of Primary Yellow, a little bit of Permanent White, and lots of water. Use your medium angled brush to paint a thin strip of sea along the top of the sand. Mix a little bit of the blue with some of the sand mixture and add lots of water. Paint an area where the sea and sand meet using this color.

03

Mix up a light blue for the sky using Permanent White and Primary Blue. Paint the sky in broad, loose brushstrokes with your medium angled brush, leaving white space for the clouds and a line of white space between the sea and the sky.

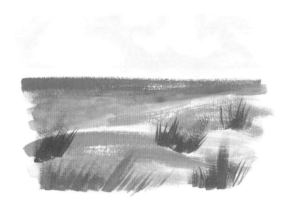

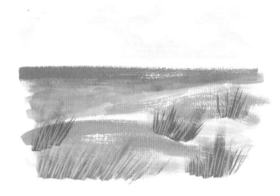

04

Mix a green color using Yellow Ochre, Primary Blue, Permanent White, and some water. Use your medium angled brush to paint tufts of grass. Start your brushstrokes at the bottom and pull the brush upward—the brushstrokes should finish in a rough, tapered stroke. Using the flat of your brush will create wide, textured brush-strokes; turn the brush 90 degrees to create thin brushstrokes using the thin edge of the brush. Pull the brush from bottom to top in the same way.

05

Add more Permanent White to the green mixture and use the thin edge of your medium angled brush to add long thin blades of grass over the areas of grass you've just painted. Add more white to the mixture and paint more blades of grass in the foreground.

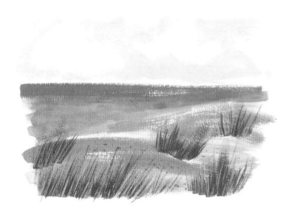

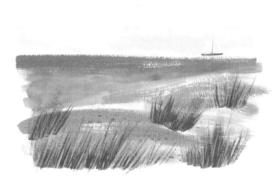

06

Add more Burnt Umber to the original sand color and paint small pebbles dotted over the sand using a small round brush. Mix Ultramarine and Yellow Ochre with a little bit of water to create a dark green and use your small round brush to paint more blades of grass.

07

Using Permanent White and your small round brush, paint two long triangles to indicate a sailboat on the horizon. Mix a light gray color using Permanent White and Lamp Black and paint the hull and mast, and add shadows to the sails. Use Flame Red and your small round brush to add a thin line to the hull of the boat.

Once you feel confident painting
this project, why not try combining
it with one of the other projects
from the book, perhaps adding a
pair of dogs or a woman walking
on a wintry beach.

Final Thoughts

I wrote and illustrated this book to cover a selection of subjects you might be interested in painting and, more important, to teach you a whole range of gouache techniques and skills, which you can apply to any subject. Once you're feeling confident and have completed some of the projects in the book, start applying the skills you've learned to paintings from your own imagination.

People often ask me where I find my inspiration, and the truth is everything is inspiring if you look at it the right way. In my daily life I'm influenced by color combinations in the tube stations I use every day, interesting outfits that people are wearing, funny situations that occur in life, and so on. Inspiration is everywhere. People often turn to the internet for it, but that can be a bit of a double-edged sword. There is a thin line between being inspired and just being overwhelmed by the wealth of beautiful work you can find online. I always find it much more motivating to visit a new place, go to an exhibition, read a book, or even watch an old film. Paint the things that you genuinely love, and don't worry about what you think you should be painting. Your sources of inspiration will contribute to your own unique style and body of work. Having a broad range of creative sources is a really good thing and makes your work unique to you.

People often worry about finding their artistic style. I always think everybody's style is like their handwriting, it's intrinsic to them. When I teach workshops, everybody paints the same object with the same paints and same brush, but each painting looks different. Everybody's artwork will have a unique quality due to their brushstrokes and line work. I don't think it's a good idea to try to choose a style that you think is on trend and produce work like that. It's important that your style feels natural to you and reflects the way you see the world. Don't worry about trying to find your style as quickly as possible; just enjoy the process and create as much work as possible. Also, don't worry if your style is changing. That's completely natural. It will continually evolve as you are inspired by new things, try new materials, and become more confident in your drawing and painting abilities. The number-one piece of advice I can give anyone is to just keep painting. Don't worry about making mistakes, just keep going and have fun.

Acknowledgments

Thank you to my agent, Leslie Jonath, who has always believed in me and has helped me to turn my dream book projects into realities. Thank you for your enthusiasm and support every step of the way. Thank you to my editor, Ashley Pierce, for believing in this project from the beginning and being so wonderful to work with.

Thank you to my husband, my parents, and my grandparents for their endless support. Thank you to my grandpa for always being my biggest fan.

About the Author

Emma Block is a London-based illustrator. She first discovered gouache after graduating from university, where she studied illustration, when looking for something bolder than watercolor and less time-consuming than collage. She works in publishing and packaging and licensing, as well as teaches painting workshops and writes books. She is inspired by old photos, midcentury design, travel, and dogs.

Index

for my granny,
Ruth

Copyright © 2020 by Emma Block.

All rights reserved.
Published in the United States by Watson-Guptill Publications, an imprint
of Random House, a division of Penguin Random House LLC, New York.
www.watsonguptill.com

WATSON-GUPTILL and the HORSE HEAD colophon are registered trademarks
of Penguin Random House LLC.

Library of Congress Cataloging-in-Publication Data is on file with the publisher.

Trade Paperback ISBN: 978-1-9848-5730-9
eBook ISBN: 978-1-9848-5731-6

Printed in China

Design by Nemo Liu

10 9 8 7 6 5 4 3

First Edition